FROM THE SHADOWS
Presents

BLOODY HELL

the Making of

Blaize-Alix Szanto's

BLOODY HELL

Blaize-Alix Szanto's
BLAZE of GORY

By David V G Davies
and Blaize-Alix Szanto

Additional material by

Jason D White
Duff Eynon
MJ Dixon
Simon P Edwards
Andy Edwards
Lord Zion
Robert Noel Gifford
Antoni McVay

Foreword by
Dean Sills

First Published in 2017
by From the Shadows Limited

Screenplay © 2013 From The Shadows Limited

This edition and all text within
© 2017 From The Shadows Limited

Artwork by David V G Davies

Printed by Createspace

For my Mum

"I am totally overwhelmed that this has happened all from a few stories that I wrote! I think what makes it even more amazing for me is the fact that I enjoy writing and I didn't write my stories for anyone else so when Dave asked for them I was really dubious about it. Even now, when the project has been going for nearly 2 years I'm still overwhelmed by it all."

Blaize-Alix Szanto

From an interview by Dean Sills for UK Horror Scene

Contents

xi
FOREWORD
by Dean Sills

1
SNOW

33
IF YOU WERE HERE

51
MONSTER

77
ABORT

93
YOUNG AND NAIVE

117
SICK LITTLE BOY

139
MASQUE OF THE RED RAPE

155
BEER CELLAR

183
PRECIOUS

199
THE END IS NIGH

FOREWORD
by
Dean Sills

Back in 2012 I took a career change from working as a professional painter and decorator to becoming an actor. This happened by accident when I found myself spending 5 days on a West Yorkshire film set playing a Zombie in the independent horror feature film, The Eschatrilogy: Book of the Dead. It opened up a real passion inside me for the arts, spurring me on to do more. I injected all my energy into this and continued to act in the horror genre, moving on from a supporting artist to a bit part actor to eventually leading roles in films like The Railway Carriage. I joined facebook and started networking with many talented individuals working within the industry. After working on a few other films I came across a director called Antoni McVay. Antoni was looking for actors for his segment in a new horror anthology feature film called Blaze of Gory. The feature is guaranteed to shock and disturb in many ways. I applied for a small role in Antoni's segment which was called Young and Naive. I originally was only going to be a supporting artist but to my delight Antoni offered me the part of Sleazy Co-worker, working alongside the lovely Ashleigh Gloyne. Ashleigh played Corine, the female lead role in Young and Naive. She was a true joy to work with even if i did have to play a sleazy male who pervs all over her. One of my good friends Steve Pollard also worked on the film and we both travelled up to Newcastle from Leeds on July 20th in 2013 to film our scenes. Looking back it was a wonderful time and a huge honour to be involved in such a fantastic project. The filming went well and meeting Antoni McVay along with Ashleigh Gloyne, Lee Bibby, Simon Craig and Elena Marie Verrall was an awesome experience and one I can look back on

with fond memories. At the time I knew very little about Blaze of Gory other than seeing the fabulous footage than had already been filmed in Norway for the segment called Snow. This segment was directed by David V.G. Davies and it looked bloody brilliant from the footage and stills I had already seen.

I have worked on many genres now including drama and comedy at Steve Call Productions but there is something very sexy about horror, the fake blood and gore along with the buzz and atmosphere each one creates on set. My acting was never going to win any Oscars for my small role in Blaze of Gory but it did get me excited knowing I had achieved something when some of the cast and crew asked if I was acting or really that sleazy in real life. The glasses I wore for my role as the Sleazy Co-Worker were my own idea and they simply do add to the creepiness of my character.

It's hard to believe that Blaze of Gory was written by Blaize-Alix Szanto, a teenage girl at the time who got into the horror scene during her secondary school years. Thanks to her mum who put Blaize in touch with David V.G. Davies who decided to turn her stories into an anthology of extreme horror with each segment getting directed by a different director. We really do have some outstanding talented directors working on this including Mj Dixon and Robert Noel Gifford. The cast is also exceptionally good with many superb actors including Martin Hancock (Coronation Street) and Nathan Head acting in the film. My daughter Rebecca Sills even played one of the victims during the scrapbook sequence in Young and Naive which was a proud moment for me as a father. David has put all his heart and soul into this amazing project and I for one can't wait to see the end result.

My involvement with Blaze of Gory carried on when the Indiegogo campaign began, I put money into the film and became an associate producer. This was another proud moment of my career in this industry and since then I have helped produced a number of other amazing projects. I have helped support the film in many ways but the best way of all was when I started writing for UK Horror Scene.Com and I got to interview many of the cast and directors who worked on Blaze of

Gory. My brilliant Editor Andy Deen gave me the freedom to interview anyone from the world of horror. At times I would aim high and interview actors like Luke Goss, Marilyn Burns and Tony Curran but I also interviewed friends who had worked on Blaze of Gory including Nathan Head, Rudy Barrow, Antoni McVay and Mj Dixon. My first Blaze of Gory interview at UK Horror Scene.Com was in September 2013 with the lovely Susan Adriensen. Susan had worked on the segment, Snow and she talked about her time in Norway working on Snow, which is a modern day Snow White story with Susan playing Reyna, the evil stepmother. After Susan I interviewed Damien Colletti who worked on the segment, Masque of the Red Rape, directed by Robert Noel Gifford. This is the only segment filmed in the USA. I am looking forward to this segment since I am a fan of Robert Noel Gifford's work. Other interviews followed including Victoria Broom, Sabrina Dickens and Sandra Veronica May. Both Victoria and Sandra worked on the segment, Monster. Monster was directed by Andy Edwards and it's the one that excites me the most after seeing a teaser trailer for it. I soon moved on to interviewing the directors who worked on Blaze of Gory, starting with Jason Wright, I soon ended up interviewing 8 of the directors which was a great feeling and it helped me know much more about this amazing film.

I can't wait to see Blaze of Gory once the film is released. So far I have only seen the segment I worked on. On November 23rd at Bar Loco in Newcastle Upon Tyne I attended the Cutting Edge film festival. It was great catching up with Antoni McVay, Lee Bibby and Simon Craig again and I did enjoy watching Young and Naive. I never feel comfortable watching myself on screen as an actor probably because I judge myself too much but I did enjoy my small role in this fab segment. Antoni did an amazing job as director and actor in his wonderful segment. The drill scene is my favourite moment, it's bloody brilliant and looks quite gory on screen.

The segments I can't wait to see the most are Monster, Snow, Masque of the Red Rape and If You Were Here. If You Were Here was directed by one of my favourite Indie horror directors Mj Dixon. I have been lucky when it comes to acting because I got to work for Mj last year when I played Sheriff Hoffman in his film, Cleaver: Rise of the Killer Clown. I loved every moment even if it was another small role. Thanks to films like Blaze of Gory I played the lead role in The Railway Carriage, a

short horror film directed by Ross Adgar which has screened at a number of film festivals. My passion for horror continues even if I have moved away with comedy projects like Up North. Thanks to my good friend Steve Call for taking on my project and Essex TV for showing Up North on their channel. I now feel I can have a go at writing horror and I do have a couple of good ideas so you never know. I want to thank Blaize-Alix Szanto and David V.G. Davies for giving us a Blaze of Gory.

David has taken on a very ambitious project bringing together the best from the independent world of horror, each segment takes us on a terrifying journey which is more scary than the ghost train ride at Skegness. If you love horror please support this film, if you don't love horror give this one a try you never know you just might like it!

1

SNOW

"At least no one spoke of her again, until just now that is!"

'Reyna'

It was 2012 and I had been working on a film, producing the Electronic Press Kit. I had previously worked with one of the producers before on a film called Forest of the Damned 2 and he and I were toying with the idea of creating a website to showcase British horror talent. This was something that I was particularly fond of as it was the same goal I had while working for a horror magazine a few years previous. Eager to make a start on this website, I put the feelers out for aspiring filmmakers, artists and authors to get in touch but sadly, the postman was not knocking down my door, so we decided to abandon the idea and continue with the readily available paid work. I finished the EPK and went on to work on another film. In between film jobs I would occupy my time in positions of retail and have done near enough every job possible. It was during one of these jobs that I became friends with the staff of a neighbouring shop, they made cakes and you don't get a figure like mine from eating salads so needless to say, I was in there quite often. The staff took interest in my stories of working within the Independent Horror circuit and one of the staff mentioned that her daughter had written a few horror stories, excitedly I said I'd love to have a read and honestly thought that would be the end of it.

<p align="center">I was wrong!</p>

I remember the day I met Blaize, a girl who stood out not just because of her neon pink hair, but also for the fact she was well spoken and could hold an intelligent, well structured conversation with you. It was very rare in the town to find someone that A, you could understand and B, did not expect to see them degrading themselves on the Jeremy Kyle show the very next day.

Blaize showed me one of her stories and instantly I was impressed, not at just the sheer horror on the pages in front of me, but the fact she was only 12 when she wrote it.

I contacted my producer colleague and asked if he was still interested in working on the website we had spoken of, sadly he was now in a different field of work and not interested in pursuing that venture.

There was no way I could not promote the work of Blaize, it needed to be seen, so I spoke with her in detail about how I felt this story would work as a film. The story in question was a sinister version of Snow White. I am a huge fan of the dark undertones within fairy stories and was eager to see this talent in writing brought to the screen.

Seeing the potential, I asked Blaze for more stories and within a few months the idea of Blaze of Gory came to life. I was very interested in seeing her stories branch the gap from page to screen and it enabled me to bring together a large crew of talented people all looking for the recognition they deserve. I have been blessed to have encountered numerous people in the industry over the years, and decided once again, to put the feelers out.

It was from this point on that Blaze of Gory began to take shape and after four months of preproduction we had a script ready and almost a full crew. To get production rolling I chose to direct one of the segments myself and it was only natural for me to pick the story that started the project.

In the beginning there was no particular set order for each segment, all that was set in stone was I would be the first to direct to get the ball rolling and that the wraparound segment (later titled Precious) would be shot last.

A few delays did occur, but that was only to be expected with the limited budget.

The eventual schedule worked out like this.

Film title	Director	Shooting Schedule	Pickups	Location
Snow	David V. G. Davies	14-16 January '13	March '13	Kongsberg, Norway Crawley, W.Sussex
If You Were Here	MJ Dixon	March '13		Milton Keynes, Buckinghamshire
Monster	Andy Edwards	13 May '13		London
Abort	Yana Kolesnyk	19/20 May '13		Crawley, W.Sussex Croydon, London
Young and Naive	Antoni McVay	July 20 '13		Newcastle Upon Tyne
Sick Little Boy	Simon P. Edwards	August '13	July '14 Re Shoot	Norwich, Norfolk
Masque of the Red Rape	Robert Noel Gifford	August '13		Long Island, New York
Beer Cellar	Blaize-Alix Szanto	4-6 October '13	May '14 directed by Lord Zion	Pontyclun, Wales East Grinstead, W. Sussex
Precious	Jason Wright	April '14	May '14 directed by Lord Zion	Horley, W. Sussex East Grinstead W. Sussex
Opening titles	David V.G. Davies	July '14		Horley W.Sussex
End Credits	Chris Yardley	September '15		Glasgow, Scotland

You would be mistaken for thinking that the first segment to be filmed would be one of the easiest. Being that the project was my brain child, I felt it only fair that I be the one to start the ball rolling and allow the other parties involved to know that this was indeed a real project. I had only worked with one of the directors before, but had helped promote some of the others, so it seemed right for me to start things off. The story I chose to direct was a sinister version of the Grimm Fairy Tale, Snow White. I had always wanted to make a fantasy film having been inspired at a very young age by the Jim Henson and Frank Oz film, The Dark Crystal (1982). Having previously made a couple of very low budget films I wanted to up my game, I knew that I could do something better and this was the story that would help me achieve that. I thrive to improve with everything I do and this project was filling me with excitement. With the story I chose to develop, I was faced with all manner of source material, not just from the fantastic story written by Blaize but also from the film interpretations that were also inspired by the same original story. Blaize's version held some fantastic imagery and excited me to bring it to the screen.

Original Short Story 1:
Snow White

So...

You want me to tell you the story of my stupid little stepdaughter? Well fine if you insist!

Once upon a time yada, yada, yada you get the point, there lived a beautiful young girl who went by the name of Snow White. She was so pretty that everyone loved her! I was so jealous of her that I brought a tissue. Everyday I would go to it and say tissue, tissue in my hand, who is the fairest in the land? Despite all my efforts to be the prettiest in the whole land the damn tissue had to go and say it is Snow White, Snow White is the fairest in the land.

In the past I tried to treat her as my daughter but I never really liked her, and I was only married to her precious little daddy because he was rich beyond my wildest dreams. As soon as he died or was murdered should I say, by me of course, I immediately took the money which was meant for his so called darling daughter. But what he didn't know was that she liked to talk to the poor woman who often walked past their house, this she was forbidden to do. I tried to stop her from getting new clothes and getting dressed up but everyday the tissue would say the same thing. After many hard years of trying to make her ugly I made her leave the house with my tailor (a hired assassin), I told him that he had to slit her throat, cut off her arms, first by the wrist, then the elbow, then finally the shoulder and to do the same with her leg, cut it off at the ankle, then from the knee, then finally the groin. After that I also ordered him to bring me her eyeballs pulled out from the sockets, her heart cut out from her chest neatly and last but by all means not least her head.

So out to the forest they went talking of how great Snow White thought her life was little did she know of what trauma lie ahead of her.

As they walked through the dark, damp, dreadful forest, Snow White suddenly urged to the 'tailor', "I know why you have brought me here," The tailor jumped back with astonishment. "But if you are going to kill me just do it quickly!"

"I would do no such thing to a beautiful girl such as you!" replied the tailor.

"Well let me make a deal with you, instead of killing me you can just run away and not have to face up to the queen." Suggested Snow White.

"That sounds like a good deal."Sneered the tailor. The tailor bent down as if to take his bag but in one quick, smooth swipe of his 15 inch blade her foot was gone along with her money and the tailor. As the blood flowed from her foot with searing pain she wept into her dainty hands.

"Oi get off of my log!" Came a high pitched but strangely masculine voice. Snow White still wept silently. Clasping the lower part of her leg, she dragged herself along the floor only to find herself at the foot of a tiny dwarf. The dwarf looked at Snow White with a puzzled look. She wept still, with blood flowing from her leg as red as rubies. The dwarf wolf whistled and suddenly 6 other tiny dwarves gathered around her, each one slightly taller than the other. Suddenly the dark and dingy forest became vibrant and bright.

"Heave Ho, Heave Ho!" yelled the dwarves as they swayed a now unconscious Snow White to and fro. In the blink of an eye they let go and she flew like an elegant bird through the air. Drip, drip, drip went the blood from her foot and down, down, down went Snow White. CRASH!!!!!!!!!!! Her whole body jolted forward and then stopped dead in front of a little, black, wooden door. One by one each of the dwarves stepped over Snow White as if she was just a log in their way. The last dwarf dragged her in by her hair and sewed on a foot of wool stuffed with wood to walk on and straw for softness. Then they cut off her other foot and did the same but this time they forgot to make the straw foot before they cut off her foot. By the time they had made the foot poor little Snow White had lost a lot of blood. As they were sewing on her foot she awoke with a fright.

"AAAGGGGHHHHH!!!!!!!!" Wailed Snow White. "Where have my feet gone?" With a bang she fell to the floor.
"She's out cold." Exclaimed one of the dwarves.

After many, many, many episodes of fainting Snow White finally realised what had happened to her. She could not say thank you to the dwarves enough, but if she knew what they had done to her while she was unconscious god would she be angry! What no-one knew was that I hired the dwarves to give her the worst time of her life, in the hope that it would lead to her suicide. All the stupid fairy tales these days are all princesses and fairies and princes and witches, but this one is nothing like those idiotic excuses of fairy tales! But anyway enough about that lets get back to the story it's just getting good.

Snow White was so grateful that she did literally everything that the dwarves told her. Everyday she would be told to clean this and scrub that. But the dwarfs' house was so beautiful that she didn't mind, with its stain glass windows; its 7 bedrooms and bathrooms; its 35 acre garden and its wonderful view. After a while she began to get bored of doing the same thing everyday so she asked the dwarves if she could go into the woods. The dwarves had been ordered (by me) not to let her out of the house. So when she said this they immediately had to think of a plan to kill her once and for all. So one day they thought up a plan which went a little something like this: they planned to let her go outside only if she brought them back the prettiest but deadliest flowers in the forest. Much to their enjoyment she did not know that they would kill her.

So off she went into the forest with her head in the clouds. When the sky turned dark and the stars came out when Snow White didn't return to the dwarfs' house they were over the moon. But Snow white had not been killed by the flowers, in fact she had tied one end of a vine round her neck and the other end to a bridge and jumped. Days passed and the dwarves decided to see where Snow Whites body was, when they saw what had happened to her they felt really sorry for her (yeah as if!). They pulled her up and dragged her back to their house. CUT! SLASH! SAW! They cut up poor Snow White. Each day they would send me a body part for my dinner and after that she was never spoken of again until now!!!

Tissue, tissue in my hand who is the fairest in the land? Snow White, Snow White is the fairest in the land....

What Happens in the Cabin, Stays in the Cabin: The Making of Snow

This story went through many rewrites before a screenplay was settled upon and as a result certain things did change. The first element we worked on was Location. To begin with I was toying with Scotland or North Wales and then while researching cabins in the snow, I came across a Norwegian location.

After seeing this place, there was no turning back, this was the place ideal location, it was perfect and I wanted it.

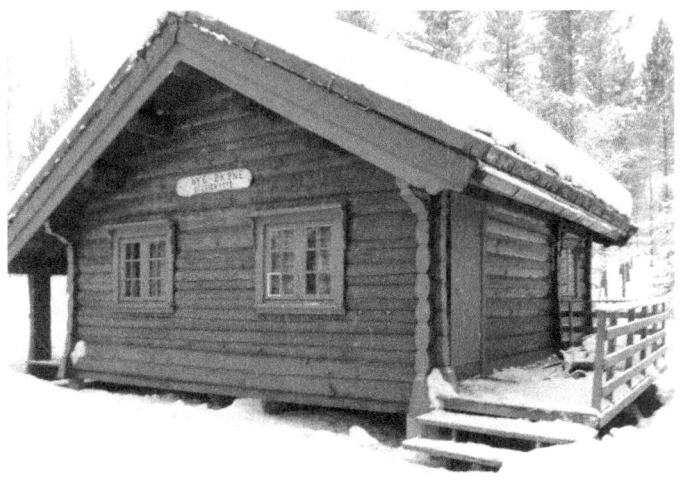

The cabin was in the middle of nowhere next to a frozen lake and at least an hour to the nearest neighbour, I just had to work out how to get there and then, how to recruit the cast. Luckily while at university I became friends with a girl that just so happened to live very near this fantastic location. I contacted her to see if she would be willing to assist me with possibly being an on set translator as I was toying with hiring a Norwegian cast and crew, I had always wanted to make a foreign film and this could be the one.

The lengthy process of casting the characters lead to the next rewrite, I could not find any actors to portray the dwarves. Speaking to Blaize we agreed to elaborate the characters of the stepmothers employees and remove the dwarves, at the end of the day, the focus of this story is that of the Stepmother, it is essentially her story.

I put out a casting call on social media stating that I was looking to film in Norway and received a surprise response in the form of Vikki Spit, I've known Vikki for some time and was delighted that she was interested, she is very beautiful and has a childlike innocence about her that would be perfect to portray a teenage Snow White. I asked Vikki's other half, Lord Zion, if he would also be interested in playing a role and he leapt at the chance.

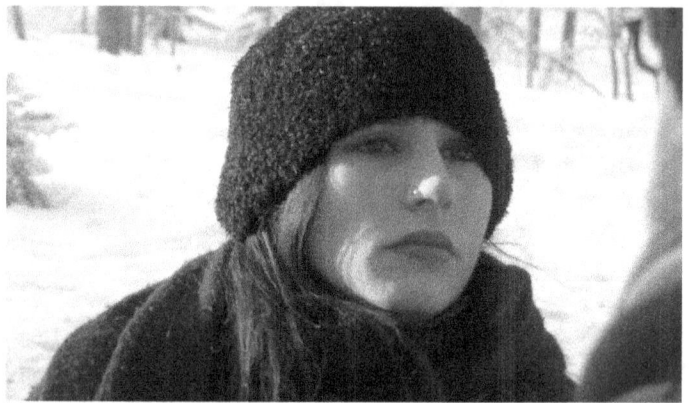

Zion recently published his memoirs which included a chapter on our escapades in Norway, in it he says...

"It was one of those bonding experiences I don't think any of us will forget. Being in such close quarters in such extremities can bring out the worse in people but, you know what, we all got on the whole time and, in those few days, became friends for life. It was, in a word, Brilliant." [1]

Lord Zion

1 A Life Amid Crisis by Lord Zion

Our lead actress happened by surprise as well, also responding to my ad was an American actress I had met in 2008 while at a film festival in Indiana and again when I visited New York when filming a thriller. She was the perfect choice for the stepmother, I could not have been happier.

"I became so excited as I was reading the script for the first time. I just loved the concept of a modern day "Snow White" story and me playing Reyna, the evil stepmother, I was honoured."

Susan Adriensen

Everything was set, the screenplay was finalised and the storyboard was completed, everything was ready and that was when we hit our first hurdle. One of our supporting cast had to cancel last minute due to work availability and so her role of the Maid was merged with that of the House Boy character, played by the very talented Duff Eynon. He was over the moon as it meant more screen time and a more developed role, it was very lucky that the script benefitted from this change.

***"Now hold still!
We don't want a wonky line now do we?"***

Houseboy

Logistically flying one cast member from New York and myself and three other cast members from the UK was looking to be a lot easier than I had planned, booking flights meant that Susan would arrive from New York an hour before the rest of us arrived from Gatwick, despite the half hour delay we had, we all met up in Oslo arrivals lounge and proceeded to pick up our rental car.

Getting to the location sadly was not such an easy task. The two hour drive from the airport was fine and we were all amazed by the stunning scenery that snow covered Oslo had to offer and used the time to run lines. The car was cramped, but being this close meant we had no option but to get along. Turning down a dark road we were close to our destination but the last two mile road leading to our location had not been de-iced as I had been informed and we slid off the road and almost fell to what was no doubt, our deaths. I did my best to keep a calm head as I was the leader of this mission and everyone was looking to me for solutions. Luckily knowing a Norwegian meant I could phone a friend who gave me the numbers for an emergency towing company. It took a while to arrive and when it did, the driver did not look too impressed. Once back on a manageable road we headed back in to town looking for somewhere to stay for the night and prep for a second attempt in the morning, it was now very late and most places were booked but eventually we found a place and the very helpful chap on the desk sorted us out with two rooms that cost the entire budget of the film! What sucked more is we only had the rooms for 4 hours and we also got a parking ticket! Norway is fucking expensive!

When we finally arrived at the Location it quickly proved well worth the wait. It was amazing, it truly was exactly as I had hoped it to be and it guaranteed that the film would have that high production value that was definitely a benefit being that I had just blown all the budget. Then we got another kick to the nuts, the solar panel was broken so we had no power and no heat. I had warned the cast we would be roughing it but I didn't expect it to be this rough and I was expecting them to kill me in my sleep. But the sheer beauty of the location fully made up for it, and as Zion put it in his memoirs;

"Without electricity, water, light or an indoor loo, this was not luxury accommodation. Clearly we were mad English people being typically, well, English and bloody stupid. But, you know what? It was alright. It was better than alright. Surrounded by such beauty and doing something interesting made the conditions somehow bearable. Enjoyable, even."[2]

Lord Zion

2 A Life Amid Crisis by Lord Zion

Vikki kept us all from certain death by starting a fire, however she did attempt to test her new found super heroine status by walking out on to the surface of the frozen lake and proceeded to jump up and down on it amazed at its durability.

FYI, deciding not to venture outside to pee in the freezing cold outhouse with no plumbing, peeing in the sink seemed like a good idea, that is until the warm pee cracked the frozen pipes and leaked out all over the kitchen floor! But in the end we had an amazing film and a fantastic location, sods law when we landed back in the UK it had been snowing!

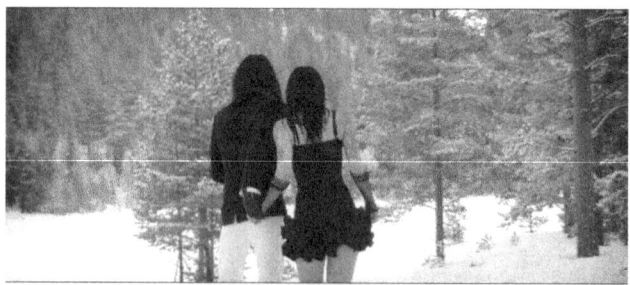

The Gore sequences of this film were shot back in the UK in a more controllable location doubling up as the wood shed in Norway. I made intestines, body parts and all manner of blood delivery systems to completely cover Snow White and our murderous House Boy, typically while filming in minus 5 degrees in Norway, no one succumbed to the cold, however back in the UK, filming in 10 degrees, pour Vikki developed hypothermia. She still talks to me so thats good and oddly, to this day, I still have her eyes on my desk!

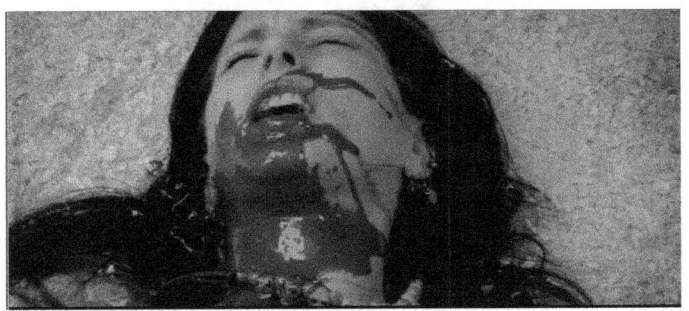

"I am still finding sawdust, that stuff got everywhere!"

"Despite nightly troll patrol, I'm still annoyed I didn't find one, but Susie did in the petrol station toilet!"
Vikki Spit

"We wrote our names in the snow much to the disgust of the girls, I think Vikki was dared to try but we persuaded her not to. It probably didn't help that we did it right outside the cabin as it was too cold to venture far!"

Duff Eynon

"Despite the harsh conditions of Norway, David and the rest of the cast and crew were real troopers! And we genuinely had a great time. I hope to work with all of them again."

Susan Adriensen

Lord Zion's Memoirs, **A Life Amid Crisis**, can be found on Amazon

Snow
Shooting script

a Film by David V G Davies

Reyna	Susan Adriensen	Co Producers	Vikki Spit
Elurra	Vikki Spit		Duff Eynon
Pete	Duff Eynon		
Vir	Lord Zion	Composer	Chris J Nairn
Postman	David V G Davies		
Prof on TV Screen	Demetri Turin		

Thanks to
Smell Your Mum for the shirts
www.SmellYourMum.com
Camilla Myrvik and Per Olav
No Thanks whatsoever to
Klaus the Wanker

Shot on Location in
Kongsberg, Norway
and at FTS Studios W.Sussex

INT. A DARKENED ROOM DAMOCLES FOUNDATION PRESENT

A single beam of light cuts through the darkness originating from the ceiling. The camera slowly dolly tracks in Sitting in the light on a chair, slightly relaxed is REYNA in her 30's she looks bitter and unimpressed, a little tired, her good looks have been worked for, her make up is perfect but a little heavy.

> **DOCTOR**
> (off camera)
> Answer the question

> **REYNA**
> (to camera)
> Huh?

> **DOCTOR**
> Tell us what happened

> **REYNA**
> (leans forward)
> Well,
> (sighs)
> fine, if you insist!
> (leans backwards)
> Once upon a time yada, yada, yada
> you get the damn point, there
> lived a beautiful young girl. She
> was so pretty that everybody
> loved her more than ME!

 FADE TO BLACK:

EXT. HOUSE, WOODEN VERANDA FLASHBACK

REYNA sits sipping a glass of wine, she looks out admiring her snow laden garden. At the rear of the garden is her beautiful stepdaughter ELURRA she is playing with a pet dog laughing and generally loving life, the HOUSEBOY, leans on his snow shovel and watches, REYNA sheds a single jealous tear she raises her designer sunglasses and wipes her face with a tissue from her pocket.

 REYNA
 (to the tissue)
 At least you understand me, you
 never judge and are always here
 whenever I need you.

She wipes her eye a slight tint of green spreads across the tissue

INT. DARKENED ROOM DAMOCLES FOUNDATION PRESENT

 DOCTOR
 (off screen)
 So you were jealous of her?

REYNA shifts in her chair uncomfortably avoiding the question.

 DOCTOR
 (off camera sternly)
 So were you?

 TISSUE(REYNA'S VOICE)
 (muffled)
 She is the fairest

REYNA looks down and to the side

 REYNA
 (angrily)
 Shut it!

INT. LIVING ROOM FLASHBACK

REYNA is standing wearing a lovely long black dress that almost hides her within the darkness of the room, she is looking out the window as the snow falls watching ELURRA dancing in the snow. REYNA removes the tissue from her pocket.

 REYNA
 (to the tissue)
 tissue, tissue in my hand, who is
 the fairest in the land?

Her hand makes the tissue talk as if a glove puppet

> **TISSUE (REYNA'S VOICE)**
> ELURRA, ELURRA is the fairest In the land.

> **REYNA**
> (angrily)
> Baaaah!

Scrunching up the tissue and placing it back in her pocket.

> **REYNA**
> (to herself)
> Fucking thing!

INT. DARKENED ROOM DAMOCLES FOUNDATION PRESENT

REYNA in close up as she pours out her anger to the camera.

> **REYNA**
> (angrily)
> Despite all my efforts, God spited me, wherever I looked, beauty spat back at me. It wasn't fair. I did all I could to stop it. Why should there be better looking people than me, its not fair. I've worked hard to look like this, why should they just be given it and flaunt it? They don't deserve it!

INT. DINING ROOM FLASHBACK

REYNA, VIR and ELURRA sit at the dining table HOUSE BOY (suited man with a well trimmed beard) is attending their duties around the table. VIR has had a few drinks and is no longer sober, he is dressed in a smoking jacket, his hair unkempt and has the look of 'scruffy rich' The table has numerous lavish food items and 2 great candle

sticks being the main light source for the room.
For several moments no one talks. ELURRA sexily
flicks her hair out of her face and accentuates
her neck while answering a text message before
putting her phone away.

REYNA
(voice over)
Just looks at her, the fucking
bitch, perfect hair, perfect
skin, look at her eyes, stunning

REYNA breathes out heavily in a sigh that shows
her disgust ELURRA leans across the table and
grabs a condiment for her meal.

REYNA
(voice over)
Everything she does just
irritates the fuck out of me, she
gets under my skin like a rash
and I just cant get rid of her.
But for him I tried my best to
treat her normally
 (to ELURRA)
So how was school?
 (fake smile with voice over)
like I give a shit you ungrateful
bitch

ELURRA, puts down her knife and fork, finishes
her mouthful, touches her mouth with a red
napkin, then clears her throat.

ELURRA
(excitedly)

well ..

ELURRA tells a story of her day close in on REYNA
looking totally dis-interested and she begins to
mock her stepdaughter. She then takes a bite of
her food while looking across the table at VIR as
he coughs.

 REYNA
 (sighs)
 And I was only married to her
 precious little daddy because he
 was rich, but even he was a
 fucking joke.

Vir beckons over the HOUSEBOY to top up his glass
of wine. He is now very drunk

Inter cut with REYNA as she looks over at her
husband in disgust

EXT. GRAVEYARD FLASHBACK

REYNA stands looking down at her nails while next
to her, ELURRA is in tears and leans over and
tries to hug her REYNA. REYNA looks shocked and
almost repulsed at this show of affection.

 REYNA
 (voice over)
 I had gotten rid of him the very
 next morning, it was simple
 really, I just poisoned his food

INT. DINING ROOM FLASHBACK

REYNA looks at her husband as he sits at the
breakfast table, the HOUSEBOY brings in the food,
he places hers in front of her then motions with
his hand that the other dish is poisoned, she
rolls her eyes and motions with her eyes that he
stop messing about and place the poisoned food in
front of VIR which he does. REYNA then anxiously
watches as VIR almost eats his food through a
collection of comedy moments he keeps almost
eating it, eventually he begins to eat but
nothing happens, she worryingly looks at her own
food then to the HOUSEBOY who shrugs his
shoulders, suddenly VIR coughs at table and
coughs and coughs then face plants in to his
dinner dead he then sits up again and erupts
blood from his mouth

EXT. GRAVEYARD FLASHBACK

REYNA and ELURRA stand over the grave slow track in

> **REYNA**
> (voice over)
> I immediately took all his money
> and SHE wasn't going to get a
> penny
> (pause)
> his so called 'darling daughter'
> his 'precious little flower',
> bleurg,
> (pause)
> Bitch!

Her eyes look from the grave to ELURRA

INT. DARKENED ROOM DAMOCLES FOUNDATION PRESENT

> **REYNA**
> (straight to camera)
> I tried to break her. I wanted to
> force her to leave but she was
> stubborn.

INT. HOUSE FLASHBACK

ELURRA is doing house work, she is looking distraught and her clothes are unclean and perhaps torn in place

> **REYNA**
> (voice over)
> Telling her that the funeral
> costs meant we had to tighten our
> pockets made her agree that she
> had to pull her weight around the
> house so no new clothes, no make
> up, only chores, no going out.
> stay within the grounds and no,
> absolutely no social life.

INT. LIVING ROOM FLASHBACK

REYNA stands in the distance, her hand with the tissue glove puppet her other hand with a glass of wine.

> **REYNA**
> (voice over)
> I thought the physical drain I forced upon her would make her less attractive to the opposite sex but everyday the tissue would say the same thing.

She stomps her feet in anger and turns throwing her glass of wine, it smashes against the wall.

EXT. DRIVEWAY FLASHBACK

ELURRA shovels the snow to clear the driveway, she is wearing a well worn jacket but she still sweats from the chores, she finishes her duty and places the shovel by the door and removes her jacket. As she does so the POSTAL WORKER arrives and stops to chat to her, she flirts with him and touches his arm as he gives her the mail. REYNA standing in the doorway storms up to them and snatches the mail from her hand

> **REYNA**
> (voice over)
> A year flew passed and despite all my efforts everyone still thought she was still beautiful,

INT. KITCHEN FLASHBACK

REYNA pulls open the drawer and takes out a sharp knife.

> **REYNA**
> (Voice over)
> I had to do something,

 DOCTOR
 (off camera)
 So YOU killed her?

REYNA puts the knife back in the draw, she looks at the camera with a maniacal smile.

 REYNA
 (Voice over)
 Not so fast

INT. DARKENED ROOM DAMOCLES FOUNDATION PRESENT

 REYNA
 (to camera)
 It wasn't fair. I tried to make
 myself forget her and treat
 myself to some new clothes but
 still she tormented me.

INT. BEDROOM FLASHBACK

The HOUSEBOY lays on the bed with REYNA astride him having energetic sex, her hair covering her modesty. She has one hand on his face pushing it away so he cannot look at her while she is looking through the window.

INT. GARDEN SEEN THROUGH WINDOW FLASHBACK

Almost POV of REYNA looking through the window at ELURRA returning to the house from the far end of the garden, she is carrying firewood.

INT. BEDROOM

REYNA more frustrated finishes her act with the HOUSEBOY and abruptly climbs off, snatches her thin black dressing gown and covers herself.

 REYNA
 So you'll do it yes?

 HOUSEBOY
 (out of breath)
 Anything

She stands with her back to the camera and looks out of the window.

 REYNA
 (voice over)
 I told him that he had to slit
 her throat, cut off her arms, her
 legs, cut off her head and bring
 me her eyes and her heart. I want
 to see her head burn in the
 fireplace.

EXT. FOREST

Scenic shots of a beautiful forest ELURRA and the HOUSEBOY walk through the woods collecting firewood.

 REYNA
 (voice over)
 So out to the forest they went
 talking of how great ELURRA
 thought her life was little did
 she know of what trauma lay ahead
 of her.

The HOUSEBOY slows down enough to walk 2 or 3 steps behind her.

 ELURRA
 I know why you are here helping
 me!

The HOUSEBOY stops and looks up at her.

 ELURRA
 But if you are going to kill me
 just do it quickly!

The HOUSEBOY reaches to his back pocket and removes a knife.

HOUSEBOY
(looking looking at his knife)
I cant do it. She made me kill your father, I cant kill you as well.

ELURRA
You killed my father, you fucking CUNT!

She lunges at him punching at him in the chest,

HOUSEBOY
I cant do it, just run away, do it, run and never come back, here take this

He hands her some money insert flashes of REYNA dancing in her underwear in front of HOUSEBOY seductively.

REYNA
(to cam)
Do not succumb to her beauty, I am the most beautiful woman in the world, I am YOUR queen, do as I say and I will be yours. Now KILL HER.

He runs after her and she slips and falls allowing him to catch up/

HOUSEBOY
(to himself)
I'm so sorry

The HOUSEBOY bends down to pick her up.

 REYNA
 (voice over)
 I knew he wouldn't fail me, a man
 is so simple to control, an inch
 of flesh will give you a mile,
 they're primitive in their
 desires, it was no challenge for
 me. in hindsight, sleeping with
 him was only to secure his
 obedience, men are so
 predictable.

ELURRA's face looks almost peaceful against the
snow, she is then pulled up out of frame. Close
up of the HOUSEBOY's feet staggering in the snow
as he carries her.

 ELURRA
 (groans)

A hunting lodge stands in the clearing The
HOUSEBOY enters frame.

 HOUSEBOY
 (sighs)

INT. HUNTING LODGE FLASHBACK

ELURRA is placed on the floor as the HOUSEBOY
proceeds to remove her shoes and socks, he then
pulls up her trouser leg and ties a tourniquet
around her calf The HOUSEBOY picks up the saw
and begins to saw off her lower leg.

A very pale ELURRA wakes up inside the lodge
looks at what goes on, screams and passes out.

The Houseboy wraps up the severed leg/foot

EXT. FOREST

Establishing shots

INT. HUNTING LODGE

ELURRA leans up, very slowly and wearily, she looks out of the tent at the bright light, she can just about make out the figure of a man standing by the lake smoking a pipe.

> **ELURRA**
> AAAGGGGHHHHH!!!!!!!! what the FUCK have you done, you cunt!

EXT. HUNTING LODGE

The HOUSEBOY stops what he's doing and looks at the lodge then back again.

> **HOUSEBOY**
> (to himself)
> May be beautiful but sure speaks ugly.

He re-enters the lodge.

INT. HUNTING LODGE FLASHBACK

The HOUSEBOY enters the lodge and looks at her she looks at him shocked he looks down at her she stops screaming and looks at him confused.

> **ELURRA**
> Please let me go, whatever you want I'm sure we can come to an arrangement, if its money i can get it for you...

The HOUSEBOY picks up his saw.

> **ELURRA**
> You don't have to kill me, you can say I am dead and you'll never see me again, I can disappear

He steps towards her and punches the camera.

INT. DARKENED ROOM DAMOCLES FOUNDATION PRESENT

Starting wide, slow dolly track in.

 REYNA
 What no-one knew was that I hired
 that ghastly man to give her the
 worst time of her life, i wanted
 her to suffer, to beg for a swift
 death. All the stupid fairy tales
 these days are all princesses and
 fairies and princes and witches,
 but this is nothing like those
 idiotic bedtime stories! But
 anyway enough about that lets me
 continue it's just getting good.

INT. HUNTING LODGE

ELURRA is laying on the ground and tied down, she is now missing her left leg from above the knee and her right arm from the elbow, her other arm has a tourniquet, she is only wearing a bloody undershirt and she looks very pale. she slowly comes to and looks around, she looks down and focuses on the HOUSEBOY standing above her, he is covered in blood and is looking very tired, he takes his pipe out of his pocket and begin to smoke.

 ELURRA
 (whispering)
 Please let me go.

She closes her eyes and after a beat, she opens them and looks around, she now sees a collection of bags all tied up. they have blood stains on them and she can hear the sound of a fly but there is another sound, that of a sawing noise. she looks around and over to her left arm, squatting above her is the HOUSEBOY he is sawing away and as she looks over she see's what it is

he's doing, he is sawing off her hand.

ELURRA'S POV

CUT TO BLACK:

 HOUSEBOY
 (looking down at her)
 Its quite difficult you know, it
 takes a lot out of you,
 (returning his gaze to what he is
 doing)
 but it's not just a simple task
 of cut along the dotted line and
 hope for the best. I have to keep
 you alive, now that's where the
 talent really lies.

He reaches for a knife.

 HOUSEBOY
 If I chop you up all in one go,
 you'll die really quickly. but if
 i take a piece here and a piece
 there this can go on for ages.
 and that's what I'm here to do,

INT. HUNTING LODGE

The HOUSEBOY straddles her and leans forward, he pulls from behind his ear a sharpie marker pen and places it between his teeth. he pulls up her bloodied shirt and begins to rip it apart while she tries to shake him off.

 HOUSEBOY
 Now hold still, we don't want a
 wonky line now do we?

She looks down and sees that he draws a where her heart is

 ELURRA
 Can't you …

The HOUSEBOY in displeasure, spits the pen lid out of his mouth and reaches for her mouth with a knife in his hand he pulls out her tongue and cuts it out pulling it up for her to see then licking it with his own tongue.

INT. HUNTING LODGE ELURRA"S IMAGINATION

ELURRA sits up inside the tent and looking over to the bagged up chunks of flesh she then exits the lodge.

EXT. FOREST CLEARING ELURRA'S IMAGINATION

She stands all beautiful again and immaculate in her white dress, the HOUSEBOY is sitting on his stool cleaning his knife, she looks down at him and places a hand on his shoulder a smile forms on her face she steps away from him he looks up and wipes his face leaving bloodied mark across his cheek she walks away from camera in slow motion, her beautiful dress billows out in the slight breeze she walks directly up to GHOST VIR he is standing in a fantastically smart suit, his arms outstretched to welcome her the HOUSEBOY puts his pipe in his mouth ELURRA slowly vanishes from sight The HOUSEBOY cannot find his lighter.

HOUSEBOY
(sighs)
bollocks!

He gets up and goes back in the lodge,

INT. HUNTING LODGE FLASHBACK

There are bits of body everywhere, some packaged up others not, intestines on the floor next to his lighter. He picks it up and leaves.

EXT. FOREST CLEARING FLASHBACK

He lights his pipe.

EXT. HOUSE FLASHBACK

 REYNA
 (VOICE OVER)
 He'd done an exceptional job, now
 what to do with all the meat.

POSTAL WORKER at the house after delivering mail, her some mail, REYNA gives him a wrapped bag of meat the POSTAL WORKER tips his hat as a thank you and walks away.

INT. DARKENED ROOM DAMOCLES FOUNDATION PRESENT

 REYNA
 At least no one spoke of her
 again until just now that is.

 TISSUE(REYNA'S VOICE)
 (muffles)

 REYNA
 (looks down)
SHUT UP

Track back to reveal two doctors standing looking down at REYNA in the chair. a close up of a clipboard on which the doctor writes down,

'insane'

 -END-

2

IF YOU WERE HERE

"I have to punish you, you naughty little girl."
<div align="right">Dad</div>

With Snow entering post production, the other film makers were itching to get their teeth in to their segments. MJ Dixon took up the task of being the second to enter production, this was only by chance as he was in the process of moving house so luckily the location and date were set by solicitors, casting was a simple task for MJ as over the years he has developed quite a following and has made several successful independent films and has faith in those he picks to work with.

The Story assigned to MJ was a mystery tale dealing more with the suspense and the inner demons of the protagonist than the devious butchery of Snow. MJ delivers films with a look of high production value, having seen his film Slasher House, I knew colour was an important tool in his film making and I was excited to see what colour scheme he was going to employ in this film.

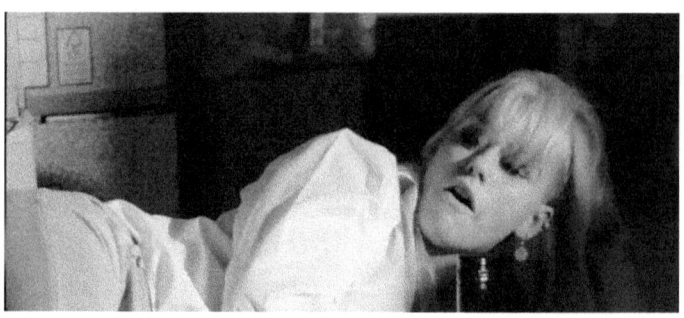

Original Short Story 2:
If You Were Here

He was standing there ready to stab; the crazed look on his face staring into her eyes as if he could feel the terror rushing through her body. He raised the knife and in a flash of red and white she was gone. The screams filled the room and he sniggered as she was gasping for her last breaths. He started touching her in ways only a sick man would. Her eyes glazed over and he carried on. The look of pleasure on his face as he pulled up her skirt...

My heart was racing and I could not watch another minute of this revolting movie. I was spending the night watching horror movies and texting my friends in my house, which had been left to me by my parents, when I found this movie hidden behind the T.V. The movie was called your fears can come alive.

Suddenly there was a bang and the hairs on the back of my neck stood up. I rushed upstairs only to find that nothing had happened. Then there was a gush of wind that blasted down the hall. I felt as if a shadow had run past the doorway but I knew it was only my imagination. I heard scuttling in the bathroom then a chuckle in the kitchen. It could not have been what I thought it was. It had to be my mind playing tricks on me. I stepped out in the hall, all these questions running through my head. I heard a smash then from the room which used to be my mum and dad's room I saw blood trickling down the door.

I thought it was just hallucinations at first but now it was becoming real. There was a faint hissing in the background which got louder every second and the beats of my heart grew faster and my breaths grew heavier. What was happening?!

I hated every second. I didn't know what to do. I just ran. I ran for the door. But then it all stopped. The hissing, the chuckling the scuttling, it all stopped. My heart beats grew calmer and breathing slowed. It was all just my mind playing tricks on me. There was no way the film could come true.

There was a sudden crash and I knew I saw a shadow this time. I did not know whether to run or go towards it. I saw the shadow on the floor. My hands started sweating. My eyes started to twitch. My feet were rooted to the spot. The big hair. The horrible smile. The dreadful eyes. The chuckle. No, no, no. Not it, not here, not now. I bit my lip and shook as it turned. It faced me now edging towards me. I wished it would just go away. I turned and ran.

As I passed the office I saw writing on the door. This writing wasn't normal. It was blood. It said words no-one would ever want to hear 'you're going to die'. Nothing was to prepare me for what I was about to see. I held tightly onto the handle and pushed. I could feel the sweat running down my forehead and the blood pulsing through my body. The girl from the movie was lying on the floor the look on her face was terror, but not the sort of terror you would see on the face of someone who had been pushed 1000 feet to their death. It was the sort of terror you see on the face who has been tortured and brutally murdered.

As she lay there with that look on her face I heard a shriek. I felt a gush of wind and then I smelt smoke. In front of me was a vampire. His teeth dripping with blood and his hands covered in human flesh. He loomed over the girl, staring onto her vacant eyes. It was as if he didn't even notice me quivering of fear in the doorway. He leant over and stroked her face. Then he started clawing. He dug his filthy nails into her flesh and ripped. He lapped up her blood like a hungry dog. He laid himself on top of her and held her head in his hands. The look in his face was almost sincere and loving. He bent down and kissed her intimately. Maybe he knew her? Maybe he loved her once? The look didn't stay for long. He sunk his teeth into her cold face. And his hands travelled down her top scratching deep.

I had to leave. This was too scary. I was barely able to walk as I slammed the door shut. The thing I saw then was awful. My heart fell to the floor and I screamed. It was my mum. She was hanging from the ceiling. Her hands and feet had been chopped off and her blood was dripping to the floor. As she swung to and fro I could not bear it anymore. Suddenly I heard scuttling. It was getting louder and louder still. No I thought, not spiders not now. My whole body froze. I could not move. I wanted to run but I couldn't.

There was a smash. It came from my mum and dads room. I felt the urge to run. Maybe my dad was in there. I ran down the hall my legs were going too fast for me and I stumbled. I regained my balance and kept running. Who was I kidding? My dad wouldn't be in there he was dead. I too a deep shaky breath and pushed the door open. I stepped in and locked the door. I saw what the smash was. The window was broken. Then I heard my dad's voice. Could it really be him?
He didn't sound like his normal self. My heart banged against my chest like a gorilla pounding on his stomach. He stepped out from behind the curtain. I gulped. He had a sick and crazed look on his face his shirt was ripped and his chest was burnt. He stepped forward. His hands were battered and he was holding a knife covered in blood. I was terrified of what was about to happen. He is my dad. He wouldn't do anything to me. Would he? He ran and lunged at me with the knife.

I fell to my knees the pain in my chest taking over my whole body. My blood seeped through my hands and I shrieked in pain. He came towards me and lay me down. He ran his bloody hands through my hair, and told me he had always loved me. He tried to kiss me but I moved my head away. He became angry now. He yanked down my trousers and started screaming at me. He was telling me I was naughty and I needed to be punished. He carved a heart into my stomach and started stabbing it. He ran his fingers down my leg. He dug his fingernails into my eyes and pulled.

She was laying there as he pulled her eyes from the sockets. He kissed her and said that she made him feel special. Only someone mentally ill would do something as sick as he did next. He shoved the knife in between her legs and twisted it. All the time he was smiling and pleasuring himself. Just to make sure she was finally dead he raised the knife and stabbed at her head. He stood up and vanished as if nothing had ever happened.

Be Kind Rewind:
The Making of If You Were Here

There is a certain nostalgia surrounding this segment that grounds it firmly in reality. One of the main props in the film is a VHS cassette, something that now is vary rare as we have since moved on to optical and now digital formats. The story is also based on an action that we all are familiar with, selling and moving house. The home I grew up in as a child holds many memories for me, as a family we didn't move around as much as others and a considerable amount of my youth was in the same house. We become accustomed with our surroundings and when we move out and return to visit our childhood homes, memories flood back. I recently had to empty my parents house and sell it and it was a very traumatic time for me, that was my parents home, my home and it was a part of me. To see it empty was very upsetting and I could never go there again. I cant imagine what it is like now that it has new occupants. I am sure its the same for anyone who has set up roots somewhere and then has to move. This film deals with those feelings and having been through it myself it felt very realistic, we are sentimental beings and our homes mean a lot to us. After the almost fantasy quality of Snow, it was very settling knowing that the Blaze of Gory anthology would cover so much ground in terms of setting, sub-genre and style of filmmaking as I knew MJ is a different style of filmmaker to myself and, as I was going to learn, so are all the other filmmakers involved in this project.

It was by chance that MJ was in the process of moving, It meant that the crew would have a completely empty canvas in which to film and although his move had been delayed previously, it looked as though now things were working well. I take my hat off to the director for being able to mentally add shooting a film to this otherwise hectic part of life.

Taking the lead role is the beautiful multitalented Jade Wallis, a model, make up artist and photographer based in Norfolk. I have recently had the pleasure of working with Jade on another project and she is so much fun to work with, she knows when to have a laugh and when to be serious, her professionalism shines through on set as she wants to give the performance that the director wants. She is definitely one to watch and I hope that this film will sit proud on her growing resume.

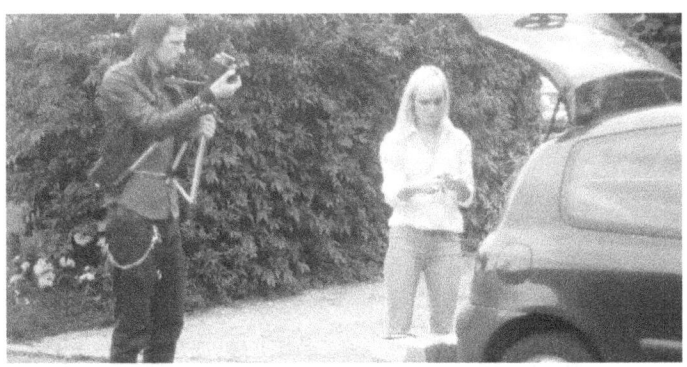

As with Snow, filming was scheduled to took place over a weekend. With MJ utilising his trusted crew, he delivered a final cut very quickly. It was at this point that I decided that all the films should have the same title sequence and as part of that I asked the film makers if it were possible to add clips of their previous work as almost a subliminal blast of gore with a bold title for each segment. This idea also allowed me to incorporate Blaize's actual handwriting.

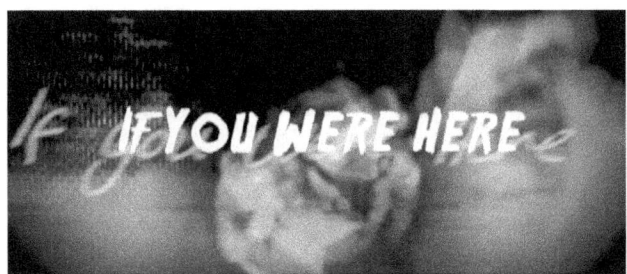

If You Were Here
Shooting Script

Directed by MJ Dixon
Screenplay by David V G Davies
Additional writing by MJ Dixon

Sophie	Jade Wallis	Co Producers	Anna McCarthy
The Dream Man	Robert Chapman		John 'Bam' Goodall
Mother	Debra Mawdsley	Cinematographer	MJ Dixon
TV Girl	Evie Constanti	Gaffer	John 'Bam' Goodall
Voice of Sarah	Anna McCarthy	Make up Artists	Anna McCarthy
			Jade Wallis
Stand Ins	Anna McCarthy	Special Make Up Effects	Anna McCarthy
	Evie Constanti		
	John 'Bam In a Wig' Goodall	Editor	MJ Dixon
		Sound Design	MJ Dixon

Music :

"Sound 12"
Written by : MJ Dixon
Performed by : HockeyMask Heroes
Used with permission from : Next Dawn Records
http://hockeymaskheroes.tk

"Fear Comes Alive"
Written by : MJ Dixon
Performed by : HockeyMask Heroes
Used with permission from : Next Dawn Records
http://hockeymaskheroes.tk

Freesound.org Attributions :

Pan Zen | Hitrison | NebulousFylnn | EvinAwer | tcrocker68 | cinevid | soundims | NoiseCollector | nothayama | fotoshop | soundsexciting | j1987 | bone666138 | jacobalcook | UncleSigmond | doctorvortex | mcroce | brighella | kbnevel | JunkFood2121 | Halgrimm | MartiniMeniscus | MegaPenguin13 | drewkelly | musicradiocreative | cognitoperceptu | Nabito |

Shot on Location in
Milton Keynes, England, UK

INT. TV

A horror film is playing out on the TV (fool audience in to believing this is the main feature).
The MAN stands ready with a knife staring to the camera frantically.

reverse shot:

a GIRL, frozen with fear her eyes unable to look away from his, her whole body aching with terror.

reverse shot:

The MAN raises the knife and slashes at the camera (think JASON VORHEES crossed with JAMES BOND opening).
we see the GIRL in a flash of red. Her screams fill the room.
Close up of the MAN as he sniggers.
Close up of the GIRL as she fights to breathe, the sounds of his laughter take over as he begins to touch her intimately. as his hands head south her eyes glaze and a final tear rolls down her cheek as life washes away from her.
Close up of the look of pleasure on his face as he pulled up her skirt, a line of dribble falls from his demonic grin, his blood spattered face disturbingly close to her privates.

INT. LIVING ROOM

A YOUNG LADY is hiding behind a cushion, her heart pounding and her eyes, finding it hard not to watch, are looking both terrified and watering not because its sad but its that scary.
Wide side shot to reveal her in a darkened living room watching a tv set.
Mid shot to show almost POV of the table in front of the TV close up of the table with a VHS box on it with the films title

'FEARS COME ALIVE'.

Close up of the YOUNG LADY watching the film Suddenly there was a bang and the hairs on the back of her neck stood up.

INT. HALLWAY

She exits the living room and rushed for the stairs

INT. LANDING

She rushes in to shot and comes to a stand still, 360 pan of the YOUNG LADY and the upstairs hallway, nothing , all is quiet close in on her eyes from behind she sighs close up as her eyes roll almost in disgust at her own stupidity she turns to walk away ... at the far end of the hallway a shadow passes the door , she jumpily turns towards it.
Close up of her face as she tilts her head and quints her eyes trying to see more.
camera on the floor as she walks from it inquisitively towards the far door, her head still tilted.
The closer she gets the slower she gets close in on her face as she looks harder.

> **VOICE 1**
> (off screen chuckles)
>
> **VOICE 2**
> (off screen downstairs murmuring)

SLAM! the door to her parents room slams shut due to a gust of wind. a passing car beams an abstract light across the walls.
She goes to grab the door handle.

INT. YOUNG LADY'S MEMORY

shots of a happy MUM and DAD as they run in to that room all happily and frolicking, the jump on the bed embracing, they stop and turn to camera, MUM gets up out of bed and bends down to the

camera.
 MUM
 you ok baby?

INT. LANDING

The here and now
close up of YOUNG LADY's face

 YOUNG LADY MIXED WITH CHILD'S
 VOICE
 Mummy, I had a bad dream!

INT. YOUNG LADY'S MEMORY

 MUM
 It's ok honey, lets take you back
 to bed baby

NEWS PAPER / NEWS REPORT
husband and wife die in freak home incident

INT. LANDING

The here and now

FLASH CUT:

Reverse shot as beyond the door she focuses on the door itself as blood begins to drip down it she tries to look properly knowing its her mind playing tricks on her. she tries to shake the hallucinations from her head as a faint hissing sound begins and fights for dominance over the sound of her own pounding heart The sound of hissing gets louder and louder.
Close up of her face camera shakes the sound of hissing merges with chuckles and murmurs and an otherworldly insect noise gets so loud she bolts for the stairs and leaves the shot descending out of view.

INT. HALLWAY

She descends the final door and looks around, the camera sees in to the living room.

INT. LIVING ROOM

Close up of the TV on which is the YOUNG LADY standing in the hallway.

DISSOLVE
THROUGH THE TV:

INT. HALLWAY

Close up of her face almost in disbelief
A sudden crash bolts her senses she doesn't know which way to run, ghostly shadows across all walls she gingerly edges away from the shadows with her back to the wall as she moves towards the front door, she blindly reaches out for the door handle while keeping her eyes on the living room. her hand slides off the handle and she brings it up to her face, it's covered in blood. she falls to her floor and looks up at the door, written on the front door in blood is 'you are going to die' she cowers pulling her knees in to her chest and her eyes stream with tears, suddenly MUM falls out of the living room dead her blood soaked face hits the floor with a wet thud she is then dragged back in to the room by an arm (the owner of which we do not see) from behind the door.

LOUD pounding on the door.

She scrambles to her feet and runs back up stairs tripping as she goes she looks through the banisters at her dead mother in the opening of the living room. jumping upon her is a man (DAD) he is like an animal, his teeth dripping with blood and his hands covered in human flesh. He looms over the MUM, staring into her vacant eyes. He digs his filthy nails into her flesh and ripped. He laps up her blood like a hungry dog. then laying himself on top of her he holds her

head in his hands. The look in his face is almost sincere and loving. He leans in and kisses her intimately. He then bites her lower lip and pulls his head away with it still in his before letting it spring back in place. His left hand moves down her lifeless body across her breast and towards her thighs as he mounts her and begins to thrust he looks up and stars directly at the girl , with one hand he moves the dead MUM's face away covering it with his palm as he continues to thrust again and again.

INT. LANDING

She scrambles to the top of the stairs on all fours she turns and heads along the floor still on all fours but she places her hand in to a pool of blood. making her slip and face planting to the floor.

Behind her stands DAD.

> **DAD**
> Hey baby girl

He steps forward, looming over her, his shirt ripped exposing his bloodied chest, claw marks on his face from an attack are bleeding but his face still has a fixed grin.
The YOUNG LADY now crawling backwards (still on all fours but facing upwards) scrambling away from him, she gets in to her bedroom

INT. BEDROOM

With her bloodied hands she locks the door her heart still racing she sobs and almost sighs in a moment of brief safety she clambers to her feet and listens to the door....

.... nothing

.... she turns away from the door and
BLAMMO a knife is thrusted in to her stomach by her DAD shock fills her face euphoric pleasure

fill his she tries to scream but only silence emerges as her heart beat slows, his heavy breathing takes over a second thrust of the knife followed by a third and a fourth her head turns to camera and she tries to speak but the life is draining from her as she slumps down with her back against the door. DAD pulls at her feet laying her out flat, he pulls at her face so that she is looking at him, he leans in and

DAD
(whispering in her ear)
I've always loved you

He then moves in to kiss her but she turns her head away. disappointment forms on his face as he misses her lips and gets her cheek. his hand runs through her hair as he toys with the knife on her face with the other.

DAD
you've been a naughty girl

He runs the knife down her face, across her throat, not pushing hard enough to cut but enough to pull at the skin she tries to pull her phone from her trouser pocket but her hands are covered in blood and the phones touch screen wont work due as she desperately tries to unlock it with her thumb and it slips from her fingers his knife now cutting open her shirt and its tip circles her nipple he continues to look her in the eye, then he licks her face and while still holding the knife he pulls open her jeans zipper and tugs down her trousers.

DAD
Screaming)
I have to Punish you you naughty
little girl.

He carves a crude heart in her stomach and stabs it in the middle.

 DAD
 look at me

Leaving the knife in her stomach he digs his thumbs into her eye sockets and gouges out her eyeballs, he pulls down her panties puts an eyeball in his mouth so it looks as if its looking out as the life fully drains from her body from behind him he is kneeling between her spread legs, his left hand is clearly masturbating his right hand pulls the knife out of her stomach and goes between her legs he thrusts the knife deep in to her again and again twisting it as he climaxes the knife then comes slamming down in to her chest.

 -END-

3

MONSTER

*"She's not Cheryl fucking Cole you know?
She killed her husband by sawing his head off
with a nail file."*

'Nurse Jessica'

The title for this segment was intended as a way to lure the audience into thinking the story would be centred around a beast of some kind where in fact, the monster of the title is a sweet looking girl, a convention that Blaize has used in many stories and one that proves to be very powerful.

This story was definitely going to be one of the more talked about segments and I chose Andy Edwards to bring the monster to life. I have worked with Andy once before on another anthology and he and I wanted the same from it. I knew this would be a great film for him to work on and it would give him a well deserved break from the zombie genre of which he is most known.

Original Short Story 3:
Monster
(Synopsis Only)[3]

A girl sits in on a creaky metal bed in a small, dark cell. She is wearing a medical gown and her hands and feet have leather shackles that are yet to be attached to anything. This is Stacey, her body frail and childlike beneath the gown, only the dark circles beneath her eyes betraying her age as somewhere in her late teens, early twenties. Her hair is unwashed and lank, framing her dark eyes and bruised face. She sits there motionless. Staring ahead, staring into the darkness. Her face remains expressionless even as two sets of footsteps approach. There is the click of a lighter, and her face is briefly illuminated, the tiny flame dancing in her inky black eyes.

She has been institutionalised for decapitating her boyfriend believing him to be her abusive father. During her capture she also manages to kill a police officer. Unable to fully grasp reality she has been sentenced to a life within this corrupt facility where the staff molest and abuse to their hearts content.

Having created a slight bond with the facility manager Stacey lures him in to a false sense of security and when the chance arises she sets him, and in the process herself, on fire. She does not scream as she finally embraces peace.

[3] Some of the stories chosen for the project were still in their idea stage when selected. These were worked on closely with Blaize to enable bringing her ideas to completion

It's Alive:
The Making of Monster

I think very highly of Andy as a film maker, from the start I wanted to have him on board as I knew he can deliver the goods. With the screenplay written I handed it over to him to add his personal touch on it and I was not disappointed.

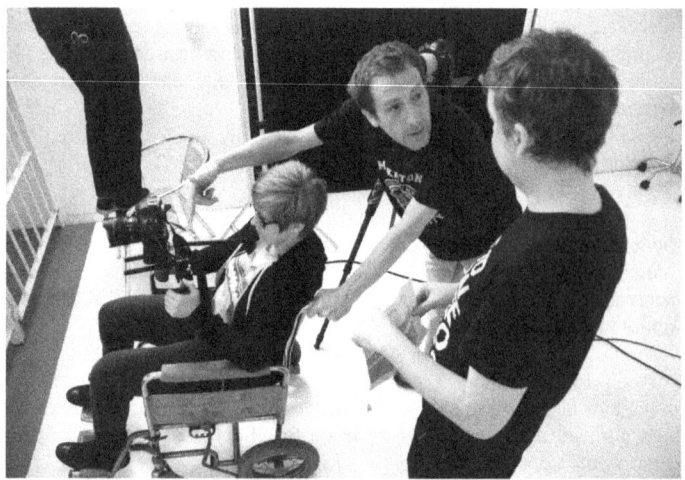

When casting this segment we were blessed with auditions for the lead role but I am so pleased with Sandra, she brought to the role the perfect element of sinister innocence and mystery. This was to be her first major film role and it is definitely one that will be memorable.

Monster was shot in a London Studio that already had the perfect set, a clinical prison cell and all manner of torture equipment adorned other rooms. It was the perfect location and really added to the films production value.

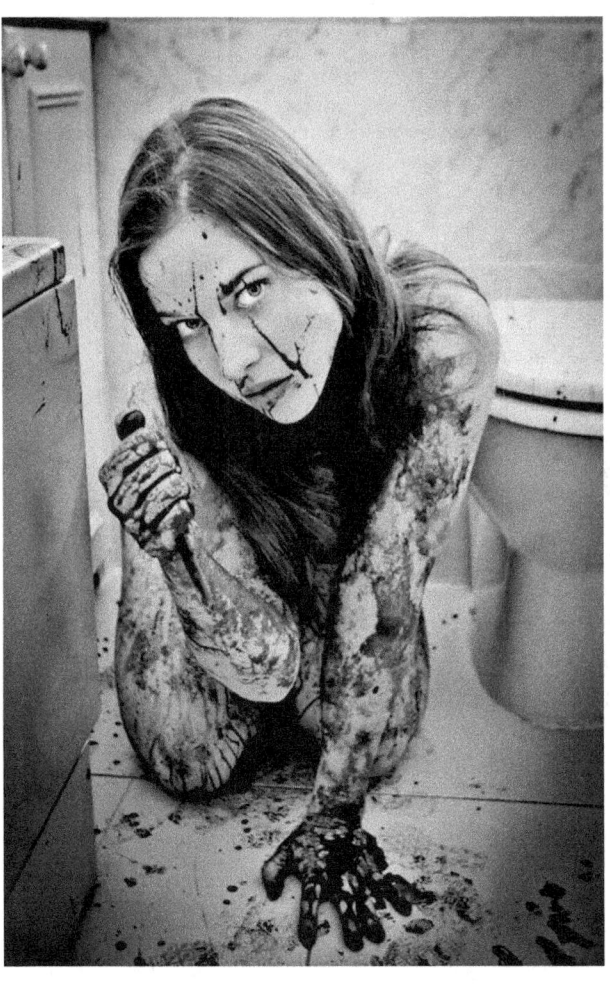

"It was amazing to play such a disturbed character, it amazes me that the writer was so young."

Sandra

Sandra is stunning, when I visited the set and was introduced to her I was confronted by a very delicate young woman sitting in a cell covered in blood splatter, I was captivated by her eyes, I remember turning to Andy afterwards and congratulated him on his choice of casting. When I was reviewing all the stills, several months later, I was convinced that Sandra was our poster girl, I toyed with other designs but she was definitely the perfect choice.

Original teaser poster versus alternative design.

We were also very blessed with the other cast members, Martin was stumbled upon at a pub quiz and agreed to be in the film. The other cast members all fit their roles perfectly and it was a pleasure to work with them.

I particularly wanted Victoria Broom to play the nurse as I had worked with her in the past where she played another deranged nurse and I wanted to link the two films with a few subtle nods.

The Damocles Foundation

Back in 2011 I made a very low budget thriller set in a hospital where the staff abuse the patients as part of their stress therapy program. The company in question was called The Damocles Foundation after an in-joke I had with my recently passed grandfather.

For that film I designed all manner of hospital paperwork, logos and sourced costumes. Not wanting to waste everything after the films completion, Ive made a conscious effort to use the props wherever a hospital or cloak and dagger organisation is needed. During the script writing process for both Monster and Snow it proved possible that they could be set in the Damocles foundation, it was especially fitting for Monster as like in my previous film, the staff here were corrupt.

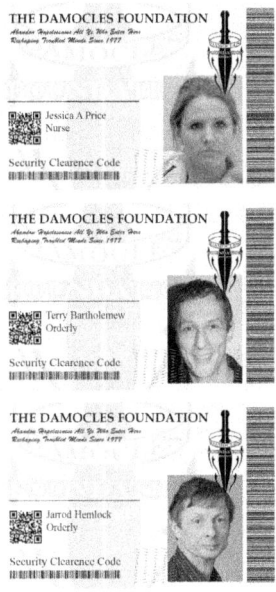

As a side note, Professor Damocles in Monster is played by Demetri Turin who also appeared in my earlier film as 'Patient 13', so it really has become like the saying, *"the lunatics are running the asylum"*.

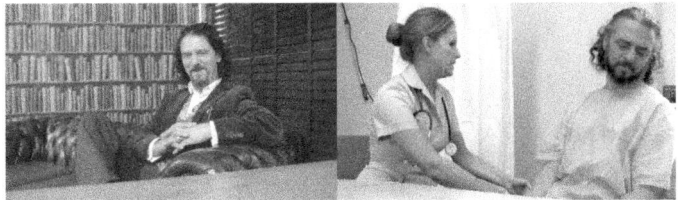

Monster
Shooting Script

Directed by Andy Edwards
Screenplay by David V G Davies
Additional writing by Andy Edwards

Stacey	Sandra Veronica Stanczyk	Co Producer	Rob Leese Jones
Terry	Martin Hancock	Camera	Laura Healey
Jarrod	Peter Saracen		Matthew Smith
Nurse Jessica	Victoria Broom		Andy Edwards
Prof. Damocles	Demetri Turin	Assistant Camera	James Godwin
Father	David Sellicks	Gaffer	Matthew Smith
Adrian	Sam Drayson LeTissier	Sound Recordist	Des Brady
Policeman	Rob Leese Jones	Make Up and SFX	Ellie Yermakova
Policeman	Paul Ewen	SFX	David Sellicks
News Reader	Sunta Templeton	Assistant to Mr Sellicks	Fenella Lawrence
Police Dispatch	Catherine Lawn	Production Designer	Kate Stamp
		Assistant Production Designer	Amy Lockwood
		Stills Photography	Enna Cooper
		Editor	Andy Edwards
		Production Assistant	Jessica Rosa
			Nayyar Mughal
		Additional Props	David V G Davies
		Composer	Chris J Nairn

Cell Artwork by Wayne Chisnall
Thanks to
Amber Erlandsson, Murder Mile Studios
Create, Unit 7B

Shot on Location in
London, England, UK

INT. CELL - TIME UNKNOWN

A girl sits in on a creaky metal bed in a small, dark cell. She is wearing a medical gown and her hands and feet have leather shackles that are yet to be attached to anything. This is STACEY, her body frail and childlike beneath the gown, only the dark circles beneath her eyes betraying her age as somewhere in her early twenties. Her hair is unwashed and lank, framing her dark eyes and bruised face. She sits there motionless. Staring ahead, staring into the darkness.

Her face remains expressionless even as two sets of footsteps approach. There is the click of a lighter, and her face is briefly illuminated, the tiny flame dancing in her inky black eyes.
The voices belong to two orderlies, TERRY, and JARROD. We don't see them immediately, just their dark shadows creeping across the cell.

 TERRY
So this is her right?

We now see the two men from the other side of the bars.

Terry is in his early twenties, with a shaved head, and cruel eyes. He sucks noisily on a cigarette, his other hand playing with his zippo lighter. Jarrod is black, in his 40s, and getting large around the waist. Both wear official overalls, with their name tags on. Jarrod holds a clipboard in one hand, and has a blue biro jutting from his chest pocket.

Terry stares in through the bars.

 TERRY
Shit. The famous Stacey. Huh.
She's like Michael Myers's little
sister or something.

 JARROD
Huh, something like that.

Terry exhales on his cigarette. He looks Stacey up and down with his beady eyes and shrugs.

TERRY
Still would.

JARROD
Trust me, even you wouldn't want to fuck with this chick.

Terry cocks his head to one side, and grins at Stacey. As ever, she remains motionless. We have no idea if she can even hear them.

TERRY
Can she even hear us?

JARROD
God knows. Damocles has her on so much electroshock, its a miracle she doesn't light up like a fucking Christmas tree.

TERRY
Does that shit even work?

Jarrod shrugs.

JARROD
She was in here as a kid you know. Bitch burned her father alive when she was eight. Damocles had her in or years - then released her, said she was cured...

He shakes his head.

TERRY
And we all know well that turned out.

Terry hasn't taken his eyes off her the whole time. Stacey still hasn't reacted. Terry turns to Jarrod, who starts what sounds like a well-rehearsed rant.

JARROD
They should leave the bloody thing on and let her brain fry if you ask me. Instead she's here - sucking up taxpayer's money like a fucking leach. Do you know how much it costs to keep her alive? The cost of the doctors? The meds, the fucking PS3s? More than I'll bloody earn in my lifetime I can tell you.

Terry frowns at Jarrod, and glances back at the cell.

TERRY
It don't exactly look like she's living the life of luxury mate.

JARROD
Enough of this shit. We've just got to complete this checklist and -

He reaches to his chest pocket for his pen. It's not there. It's in Stacey's hand. She's suddenly besides him, pulling him against the bars. The pen is in his neck, and again, and again. Blood sprays in a jet across the wall. Terry freezes enough to grab his taser and jabs it through the bars. At first it doesn't stop her, she continues thrusting away, making a bloody mess of Jarrod's neck. Eventually, she collapses to the ground. Her eyes slowly close as she loses consciousness.

INT. OFFICE

A VHS video recorder slot. A man's hand comes into frame and pushes a video cassette into the slot. We see on the side of the cassette is a label - neatly written is the words

"Stacey McDowell 15/03/98"

Then, with a clunk, the tape disappears inside the machine.

VIDEO TAPE

Static. A news report. Footage of a burning house, firefighters etc. A photograph of a man's face appears. This is STACEY'S FATHER

> **NEWSREADER**
> This fire, six months ago, killed Mr McDowell, as well as destroying the family home. His eight year old daughter Stacey was today released from hospital, and straight into the custody of the authorities. At only eight, she is too young to face criminal charges.

The footage now shows a blurred out photo of a young girl. It then switches to stock footage of the outside of The Damocles Foundation.

> **NEWSREADER**
> However, campaigners are claiming that she must face justice for her terrible crimes. For the time being, she will remain here, at the secure mental facility, The Damocles Foundation.

INT. OFFICE

Extreme close up of a brown cardboard file. Faded and worn, we can still make out the Damocles Foundation logo at the top, the word CONFIDENTIAL and the neatly written name, "Stacey McDowell". The man's hand flips open the file to reveal a bundle of yellowing pages filled with faded type. Paper-clipped to the first page are a couple of photos. One is of Stacey as a young girl, happy and smiling. The other is of her father.

INT. STACEY'S BEDROOM

A young girls bedroom, all pink & princess-like. Our shot is from Stacey's POV, staring at the door. It opens, there is the silhouette of a man in the doorway. This is STACEY'S FATHER. He steps forward into the room, and closes the door behind him.

He slowly walks towards the camera, then suddenly stops and gasps in pain. The camera pans down to reveal he has stepped on some lego that has been left scattered on the floor. The lego characters all have their heads missing, but Stacey's Father seems unconcerned by this. He hops, nursing his bruised foot.

> **STACEY'S FATHER**
> If I've told you once, I've told
> you a million times to put this
> shit away!

He steps forward, we can now finally see his face, leering and twisted, bearing down on the camera.

> **STACEY'S FATHER**
> You know what you are? You're a
> bloody little monster, that's
> what

He raises his hand, the camera swings away to look at the wall but his hand grabs it and pulls it upwards to look back at him.

> **STACEY'S FATHER**
> Look at me when I'm talking to you! Now Daddy needs kissing better.

He stands up straight, the camera now at crotch height. He slowly undoes his belt, then his zipper.

> **STACEY'S FATHER**
> Kiss it better!

He flops his penis out, all purple and veiny and filling the screen.

INT. CELL- TIME UNKNOWN

Stacey's closed eyes flutter, like she's having a bad dream. A dribble of drool slides slowly out of her mouth.

> **TERRY**
> Why are the pretty ones always insane?

He leans in, grabbing her by the hair, and licks her face in a long, exaggerated motion.

> **NURSE JESSICA**
> Why the fuck wasn't she secured properly?

Terry suddenly looks up, startled as he is caught in the act. Behind Terry, at the cell door, stands a severe-looking girl, late 20s, in a pristine nurse uniform. This is NURSE JESSICA. She glares at Terry. He shrugs.

TERRY
Fucked if I know. I only just
started down here. Probably
something to do with her human
rights or something.

NURSE JESSICA
His bitch gave up her human
rights a long, long time ago.

Terry has his smartphone out. He tugs with his free hand at Stacey's gown, exposing her breast. He clicks away, grainy, blurry pics flashing up on his phone screen.

Nurse Jessica's hand darts out and grabs his hand.

NURSE JESSICA
Jesus Christ Terry, what the fuck
are you doing?

Terry shrugs himself free.

TERRY
She's a fuckin celebrity this
one, there's websites that would
pay good money for these pics.

Jessica shakes her head.

NURSE JESSICA
She's not Cheryl fucking Cole you
know? She killed her husband by
sawing his head off with a nail
file. As if you haven't fucked up
enough today.

TERRY
I'll go fifty fifty with you?

She stares at him, her face emotionless.

> **NURSE JESSICA**
> Sixty forty. I'm gonna go and
> give B-Wing their meds, so do
> whatever you have to do before I
> get back.

She nurse steps out of the cell. Terry roughly
flips Stacey over, and lifts up her gown,
revealing her bare buttocks. He snaps away with
his smartphone, his other hand beginning to rub
away at his crotch. He turns over his shoulder to
the nurse.

> **TERRY**
> You can stay if you like -

> **NURSE JESSICA**
> I don't think so. Three's already
> a crowd.

Jessica looks down at Jarrod's body, still lying
there in a pool of blood, his throat eviscerated.
She gives it a kick with her foot.

> **NURSE JESSICA**
> By the time I get back, I want
> all this cleaned up. And as for
> *her* - I want her properly secured
> this time.

Terry blows her a kiss.

> **NURSE JESSICA**
> I mean it. And I'd do it quickly
> if I were you - Damocles watches
> these cameras you know.

The points up towards the black, blinking CCTV
cam in the corner of the room.

INT. OFFICE

A shiny computer screen. We see the side of a
man's head watching the screen, out of focus. In
the centre of the screen is a video window

labelled Cell CAM 9. We see the CCTV shot of the Nurse leaving the shot, and Terry clambering onto the back of Stacey.

The man then minimises that window, and drags his mouse to another folder. Labelled "Stacey McDowell: video files", he clicks it open to reveal a host of files, all labelled with a date. He clicks one. It fills the whole screen.

EXT. HOUSE NIGHT - FLASHBACK

A grainy video from a camera on the dashboard of a car, looking out. The digital date & time stamp, the crackle of a police radio and the continuous flicker of blue light tell us its a police car.

The police car pulls up to the front of a house, its full beam headlights illuminating the driveway. Emerging into the headlights comes Stacey. Completely naked, yet smeared from head to toe in fresh blood, she staggers into view. In one hand she is holding something. It's a head. ADRIAN's head. She throws it, and it lands with a wet thud on the dashboard. Adrian's dead eyes stare into the camera.

 POLICEMAN
Fucking hell...

There is the clunk of car doors, and two policeman appear in shot either side of Stacey. They grab her, and there is a struggle.

INT. CELL - TIME UNKNOWN

Outside of Stacey's cell, Jessica sits on a metal chair, a small fold out table in front of her. She takes a sip of coffee from a polystyrene cup and grimaces. She looks over at Terry. He leans on the handle of the mop he his holding and wipes his brow.

TERRY
You could eat your dinner off
that.

Jessica looks over. Jarrod's blood is still smeared across the floor, just now mixed with soapy water. Terry dunks the head of the mop in the bucket and goes to sit down opposite Jessica. He sighs, and looks over at the cell. Stacey is sat on the bed, arms hugging her legs protectively, in the dark corner of the cell. Her eyes are impossible to make out in the darkness.

TERRY
Suicide watch? For fucks sake.
don't get why we don't just let
her do it. Save us all a lot of
bother. How many people has she
killed now?

NURSE JESSICA
Eight, including your pal Jarrod.

TERRY
Jesus. We should take a leaf out
of ow the Chinese do it.

NURSE JESSICA
What? Become communists?

TERRY
Take 'em out the back and put a
bullet through their head.

He mimes a gun blast to the head with his hand. Jessica shrugs.

NURSE JESSICA
If I were in charge then I'd fry
the lot of 'em. All the rapists
and the pedos and the sluts.
But...

She smiles.

NURSE JESSICA
Then we'd be out of a job.

Terry scowls, then pulls a pack of cigarettes from his pocket.

TERRY
Shit, I almost forgot.

He pulls out a cigarette, and pops it in the corner of his mouth.

TERRY
I need my post-shag cigarette.

He starts to pat his pockets to find his lighter. Suddenly, Jessica's hand darts out and slaps it away from him. Terry looks at her, upset.

TERRY
What the fuck...?

NURSE JESSICA
This is a no smoking facility.
Besides, its a filthy habit.

Terry folds his arms, and slumps back in his chair. He stares at her.

TERRY
Do I make you wet?

NURSE JESSICA
You couldn't make a mermaid wet.

Jessica reaches into her pocket, and slams a large bottle down on the table. Clearly labelled "Diethyl Ether", with a
large "flammable" warning on it.

NURSE JESSICA
I brought this along to use on
her, but give me any shit and -

Terry grins.

TERRY
Ether? Old school. I like it.

Suddenly, there is a cracking noise from the cell. They both turn sharply. Stacey is standing next to the bars, with her back to Jessica and Terry.

Jessica stands up, her chair skidding backwards.

NURSE JESSICA
What are you up to now bitch?

She pulls a pair of handcuffs off her belt, where they are jangling next to a large bunch of keys. Keeping her eyes on Stacey at all time, she edges towards the cell.

NURSE JESSICA
Terry, get the Ether.

She gets closer. Stacey remains perfectly still. Behind Jessica, Terry unscrews the lid off the ether. Like an idiot, he takes a sniff, and is immediately hit by the fumes.

Jessica doesn't see this, her eyes are unblinkingly on Stacey.

NURSE JESSICA
Terry! I said get the ether ready!

Terry slumps to the floor, his arms flailing against the table. Jessica momentarily looks back to see what is happening, and Stacey seizes her chance.

She's holding the mop which she's snapped in half. She thrusts the jagged wooden end out through the bars and into the startled nurse. She drives it with such force that it punches through

Jessica's chest, bursting out of her back in a shower of blood.

Jessica gasps, gurgling blood. Stacey slowly reels her in using the pole, until she can reach out and grab the keys from the nurse's belt.

Terry tries to get himself to his feet, but he's too fuzzy from the ether. He looks up, his vision blurred and distorted. Stacey is in front of him, her eyes black pits of death. In her hand is Terry's taser. She shoves it into his mouth. Terry's body jerks as the electricity fries his brain.

He slumps, dead. Stacey steps over his body.

INT. CORRIDOR. NIGHT

A brightly lit corridor with grubby white walls. Stacey stumbles down the corridor, holding onto the walls for support. Her gown clings to her body, her hair hangs limply down, both soaking wet.

She closes her eyes, remembering.

INT. BATHROOM. NIGHT

Stacey looks straight ahead. She's in full make-up, her hair washed and brushed. She lifts a hand up to her face — she has been crying, mascara streaked down her cheeks. On her finger is the gold band of a wedding ring.
We now see she's looking into a mirror, in a white bathroom. She's standing in front of the sink in just her underwear -
a virginal white and lacy slip.
She turns slowly to the door. In the doorway we see ADRIAN. Dark-haired and handsome, and totally naked.

He moves towards Stacey. She closes her eyes. He gently grasps her shoulder and kisses her neck.

 ADRIAN
 I'm sorry I hurt you Stace. I
 didn't mean too.

He is standing behind her now, leaning over her shoulder, speaking softly.

 ADRIAN
 You promised me things would be
 different now we're married. I
 waited a long time for you to be
 ready Stace. I've been
 understanding. And now...it's my
 turn.

He gently drops the strap of slip over her bare shoulder. He kisses her shoulder, tenderly.

Stacey opens her eyes, and brushes her hair away from her face. The slip drops to the floor, exposing her small breasts. Adrian continues kissing her softly on the neck, her shoulders, but she doesn't seem to acknowledge him — instead she stares into the mirror, her eyes haunted.

For a split second she doesn't see Adrian kissing her, she sees her father, his face leering back from the mirror.

She closes her eyes, a single sob escapes her mouth. Suddenly she's grabbed the nail file from the sink and she's stabbed it into Adrian's neck.

He staggers back, blood gurgling from the wound.

INT. CORRIDOR. NIGHT

Stacey covers her face with her hands as if trying to shut out the nightmares.

INT. BATHROOM. NIGHT

Stacey sits astride Adrian, pining him down. He coughs up blood, but can't move. She starts to

saw with the nail filE through his neck. She keeps sawing. Blood keep jetting up, spraying her near naked body.

She keeps sawing away.

INT. CORRIDOR. NIGHT

Stacey continues down the corridor, her wet feet slipping against the tiles. The nightmare visions come thick and fast.

INT. CELL - TIME UNKNOWN

Stacey's POV from inside the cell. Outside, Terry and Jessica are talking, their voices an indistinct mumble, as if heard underwater.
They both turn to look in the direction of the camera. For a split second their faces flicker - both of them are replaced with the grinning visage of Stacey's father.

INT. CORRIDOR. NIGHT

Stacey smacks herself in the head, as if trying to stop the visions appearing.

INT. OFFICE

Close up of a faded photocopied form. We see the name Stacey McDowell. We see the words "Clinically Insane". We see the words "Number of victims:". A pen scribbles out the number 7, replacing it with the number 10. Then, the file is closed, and left on the desk. We pan out to reveal who has been writing on it. It's a man in a tweed suit, and bow tie. His hair slicked back, his beard neatly trimmed. This is PROFESSOR DAMOCLES. He removes his glasses, and rubs his brow. He places his glasses on Stacey's file.

DAMOCLES
Stacey. I was just thinking abut you. What a coincidence.

We now see that Stacey is behind him, standing perfectly still. Damocles slowly gets up from his chair. He has the file in one hand. He smiles at Stacey.

She doesn't return the smile.

DAMOCLES
I have your file here. Your complete history. Your life story.

He takes a step towards her.

DAMOCLES
Everyone you've ever loved. Everyone you've ever killed.

Stacey glares at him. He frowns.

DAMOCLES
You're all wet. We must get you out of those wet clothes. Warm you up a bit. Come here. Let Professor Damocles take care of you.

Slowly, Stacey takes a step forward. She sinks into the professor's outstretched arms. With his free hand, he pats her on the shoulder. His nose wrinkles. Stacey whispers in his ear.

STACEY
...not everyone...

Damocles suddenly tries to push her away.

DAMOCLES
What do you mean, not everyone?

He looks down, his wrist is locked to hers with the nurse's handcuffs. He drops the file. Papers spill out everywhere all over the floor.

DAMOCLES
What..what are you doing? Is that...ether I can smell...

There is panic in his voice now. He tries to pull away, but can't. In Stacey's other hand is Terry's gold lighter. She clicks the flame alive, and gently touches the hem of her ether-soaked gown.

The final shot we see on the CCTV, as Stacey goes up like a fire lighter. Damocles screams and screams, but the flames engulf him.

The last thing we see is Stacey's father's face, screaming from the flames.

-END-

4

ABORT

"Keep her safe, you're her mummy now"

 Boris

Short Story 4:
Untitled
(Synopsis Only)

Blaize's Notes

This story is based around a mother and her baby. While she is pregnant she does some very bad things. She murders the father of her baby and she also poisons her family. Then, while she is giving birth, she dies.

I was thinking that in the part where she gives birth there could be a part where you see a little black spot travel through her body and into the baby when she is dying which is effectively the 'evil'.

After this you see the whole of the child's life go by, you see it grow up and it is very dark. It sleeps outside and only comes out at night and kills all of the people that give it any trouble. All the time this is happening you never see its face and then when you do it is really deformed. Then it could end with it running towards the camera because we have seen its face.

за лаштунками
(Behind the Scenes)
The Making of Abort

 During the adapting from story to screenplay, the initial synopsis for what was to become 'Abort' interested me a great deal and was one of the shorts that I would have loved to have had the opportunity to direct myself. While developing the story and giving it a location, I was inspired by the David Cronenberg film 'Eastern Promises' and the idea of setting the story in the Russian criminal underworld of London just seemed perfect and made choosing a director so much easier. I had the pleasure of meeting Yana when I was promoting my first film in Leicester Square and was impressed at the time by her energy, I knew that one day we would work together and I have since had that opportunity on more than one occasion. Yana, along with her great energy, has an element of dark comedy lurking within her. I knew that this film was ideal to allow her inner darkness to shine through.

 Casting of Abort was a pleasure, I have, over the years worked with some very talented actors. Instantly I wanted Rami Hilmi to play Boris, I have worked with him a few times before and knew he would bring his 'A Game' to the role. Bizarrely once again his final scene in this segment echoes that of all the roles I have directed him in previously, It has become a running joke between us that this will be his outcome in everything we collaborate upon.

The role of the Woman and her rarely seen offspring, was played by Jenny, she is a great girl and one I really love to work with, she brings laughter to set and she is more than happy to get covered in blood, so long, as she kept telling me, that it doesn't get in her hair!

" The film was so much fun to be a part of, I love being covered in blood, I find something very sexy about it."

Jenny Miller

The other roles fell in to place and Yana and our stills photographer Olga, both hailing from the east, were able to coach the actors on their dialect.

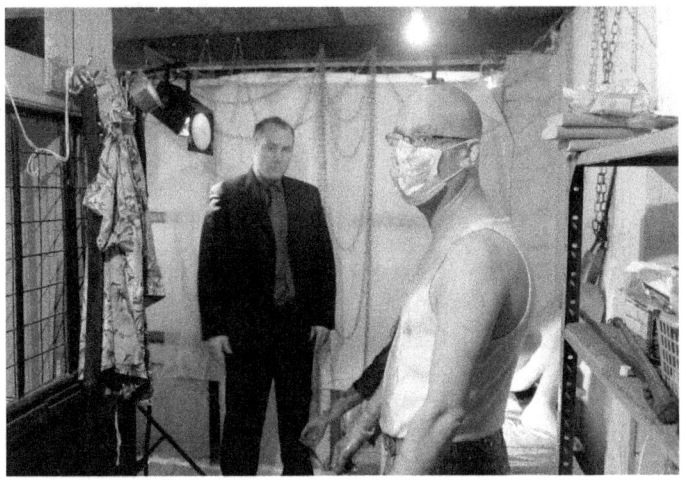

Antony and his wife Amie took on the roles of the Russian Mob Boss and one of his whores grown up, I was very nervous having her on set as at the time she was pregnant and I felt the subject matter of this film would be upsetting. Luckily she was a trooper and a few months later a proud mother.

The majority of the film was shot in my garage which at the time was basically a house for my Rottweiler who was very put out by all these people in his bed and would regularly come and have a nose around. All the cast took a shine to him and he became the most looked after character on set.

The exterior shots were completed in Croydon and fit perfectly with the desired look the film took three days in total with one of the smallest crews of the anthology, Snow and Masque of the Red Rape being the only ones with a smaller crew. Abort was the second film to be shot and, like Snow, one of the stories that I'd personally like to see as a full feature.

The gore in this segment was such a pleasure and one that made the crew cringe considerably. Jenny was an absolute trooper, she operated some of the blood delivery herself and relished the idea of it, "..more blood.." was pretty much all I heard from her during the scene along with plenty of giggles. Considering the content of the disturbing scene, she helped make it a fun experience for the cast and crew

It was at this time we were noticed by the news who covered our progression of the project in the local paper which then got us featured on the regional BBC news and local radio station.

When the BBC asked for some clips to include in their news program I found it very difficult to find footage that would be acceptable for a 6pm news slot but luckily with Snow and Monster we had some footage that would be acceptable.

Coverage of this kind was amazing and both Blaze and I were over the moon, looking back, I had no idea at the time that it would be such a long process from this point until the film would be complete. Personally for me I had to deal with a family tragedy which understandably held up post production considerably. But the film benefitted from a step back and re evaluation. We reached a peek of hype that was difficult to maintain due to the restraints of limited time on the project.

The BBC interview can be seen by scanning the above code

Abort
Shooting Script

directed by Yana Kolesnyk
Screenplay by David V G Davies
Additional writing by Yana Kolesnyk

Woman/Creature	Jenny Miller	Co Producer	Yana Kolesnyk
Boris	Rami Hilmi	Camera / DOP/Lighting	David V G Davies
Stanislov	Antony Barden	Stills	Olga Maya Matkovska
Andrei	Martin Wilkinson	Sound Recordist	
Girl aged 20	Amie Edge	Make up/Prosthetics	David V G Davies
Girl age 8	Elisha Oak	Editor	David V G Davies
		Dialect Coach	Yana Kolesnyk
Stand ins	Micah Oak		Olga Maya Matkovska
	Elisha Oak	Music by	Synoiz
Prof on TV Screen	Demetri Turin		and
			www.FreeSFX.co.uk

Thanks to
Claire Oak, Yana's Mum, Eiffets and Reggie

Shot on Location in
FTS Studios, West Sussex and Croydon, England, UK

INT. KITCHEN

Slow track across floor of the kitchen. The camera comes to a stop on a WOMAN sitting on a chair, she is heavily pregnant, her dress knee length, her long dark and dirty hair is draped forward so we cannot see her face, her head is lowered as is her arm, in her hand is a bloodied knife.

CUT TO:

INT. KITCHEN - Flashback

A MAN enters the room, he is dressed scruffily and is a workman, his tool box /bag is dropped to the floor as he walks past his pregnant wife putting his hand on her shoulder as he passes. Close up on her face again her hair is draped forward and without moving she follows him with her eyes which are only just visible amongst her hair.

CUT TO:

INT. KITCHEN - Flashback

She is stabbing him with unrivalled anger.

INT. KITCHEN - Here and now

The camera tracks backwards. We now see the bloody mess all over the walls and the body of the MAN on the floor, the WOMAN still seated in her chair.

INT. HALLWAY

The camera still tracking back from the kitchen turns in its tracks and moves to enter the living room

INT. LIVING ROOM

A bloody mess on the walls and floor, a hand of a body is visible from behind an article of furniture.

INT. HALLWAY

The camera tracking backwards out of the living room and in to the hallway, we can see the WOMAN is no longer in the kitchen, the camera continues to track backwards out of the open main door.

CROSS FADE:

EXT. STREET/ALLEYWAY

The WOMAN walks slowly away from the camera holding her stomach with one hand and occasionally using her left to steady herself against the wall, a bracelet she wears jingling every time she does so. She is barefoot and dirty from all the killing and generally uncleanliness.

EXT. RUSSIAN BUTCHERS BACK ENTRANCE

The door way and BORIS standing at the door smoking a cigarette is all that fills the frame, his Russian prison tattoos on his hands let us know he is not one to trifle with. The woman stumbles towards him and hands over a wad of money. He throws his cigarette butt away, then opens the door to let her in to the building.

INT. DIRTY CORRIDOR

It's very dark, the limited lighting just gives us a glimpse of this nasty place, little to no decorations, this is clearly the rear part of the building and the living area of the property. BORIS leads the WOMAN past a room in which is a YOUNG GIRL (teen) handcuffed to a bed but sitting on the floor, she is barely clothed and both underfed and dirty. Boris reappears and from his pocket he pulls a candy bar and passes it over to

the girl.

INT. ROOM

The door opens and BORIS leans in allowing for the WOMAN to enter. She enters the room and BORIS closes the door behind her. She looks around the room, it is very sparse, all that is in the room is a nasty looking bed and a table, on which is a metal coat hanger and a whole bunch of nasty crude implements. From the door enters STANISLAV he is wearing a butchers apron, he is approximately 40 years old, he says nothing. He points to a gown on the bed then turns his back on her. In the background and out of focus she strips down and puts on the robe. STANISLAV in the foreground in perfect focus tinkers with a medical instrument, the WOMAN sits on the bed and lays down. STANISLAV turns to her and steps forward filling the screen.

CUT TO:

INT. ROOM

The birthing scene this scene will act as a montage Close ups of her strapped down and pulling against them Flashes of WOMAN heavy breathing. Flashes of STANISLAV wearing a mask Flashes of WOMAN screaming. close up on her eyes, they are black, the colour drains from them.

INT. ROOM

STANISLAV wipes his brow, a look of disappointment on his face. He takes off his gloves and throws them on to the WOMAN who we can see has died during the procedure. The sound of a baby screaming can be heard.

 STANISLAV
You said you could dispose of a body right?

BORIS
A baby, yes, but not this.

He points to the dead woman.

STANISLAV
I don't care just do it, and you never saw her, right?

He forces a saw on him and leaves the room

STANISLAV
(to himself)
Fucking stupid bitch dying.. fuck.. least she paid up front!

BORIS
(putting a cigarette in his mouth)
Amateur fucker.

He turns to the woman then looks to the floor at the unseen baby.

BORIS
(in Russian with English subtitles)
What about the kid?

STANISLAV
(off camera)
Who cares, just get rid of it. That's what she paid us to do.

BORIS
(to himself)
Shit.

INT. POV BABY

Looking up at BORIS who is looking directly back at him. the baby's arm enters shot and the focus pulls from the hand to the dead mothers wrist with its bracelet, BORIS looks at the dead WOMAN,

notices the bracelet on her arm and then removes it.

INT. YOUNG GIRLS ROOM

BORIS drops to his knee

 BORIS
Keep her safe, you're her mummy now.

He then gives the young girl the bracelet

TITLE CARD 12 YEARS LATER

EXT. RUSSIAN BUTCHERS BACK ENTRANCE

BORIS, now a bit older is again standing by the door smoking a cigarette, a suited man gives him money and is let in. BORIS counts the money and puts it in his pocket exiting the building is ANDREI eating an over the top sandwich, it's basically falling apart and bits are dropping to the floor.

 ANDREI
Fucking hell dude, that bitch in there, can she fucking suck or what?

Boris rolls his eyes.

 ANDREI
 (slapping Boris's arm)
Whats the matter fag, she not your type?

 BORIS
 (takes a drag of his cigarette)
Leave her be, she's a good kid.

 ANDREI
So you have fucked her?

Boris smiles Andrei taps his shoulder and gives him his sandwich and takes Boris's cigarette then

walks off.

BORIS goes to take a bite then pauses, his attention switches from the sandwich to the rubbish stacked to the left. He then holds out the sandwich to the rubbish area From behind a piece of rubbish the hand of the KILLER reaches out and grabs it.

CUT TO:

Close up of the dark space where the KILLER dwells, we cannot see her, but can hear her breathing.

INT. ROOM

The YOUNG GIRL, handcuffed to the bed. She is the girl grown up she is still wearing the same t shirt but it is now faded.

Boris stands at the door smoking a cigarette, in his hands he has a foil container of food. He places it on the floor and pushes it to the girl. The GIRL picks up the container and kneels next to the bed, as if offering it to someone. From under the bed an arm lashes out and grabs the container. The GIRL's bracelet jingles as the container is pulled away from her.

Close up on an unknown person under the bed, the KILLER's eating makes a horrid noise.

FADE:

INT. ROOM

The YOUNG GIRL is on the bed while a large HILLBILLY is having sex with her. Her face completely still with no emotion, she blankly gazes into space.

The HILLBILLY gets annoyed and slaps her around the face. A growl is heard from under the bed. The HILLBILLY didn't hear it and continues to hit

her. Suddenly the HILLBILLY is pulled out of shot, the YOUNG GIRL, shaken, pulls her knees up and looks shocked as blood sprays up at her from off camera. STANISLAV enters the room quickly and looks around, the body of the HILLBILLY is in the corner but the killer cannot be seen, STANISLAV looks over at the YOUNG GIRL.

STANISLAV
Bitch!

STANISLAV grabs the YOUNG GIRL and slaps her around the face. The KILLER leaps at him from nowhere, knocking him to the bed, it leaps on top of him pounding his chest until he dies.

BORIS runs in to frame, he looks on shocked and steps forward. The KILLER is no where to be seen so he attempts to comfort the girl, putting his gun away.

BORIS
It's OK now.

ANDREI rushes in and seeing his boss murdered and believing that Boris is to blame, shoots Boris in the back of the head, he then looks at the girl and shoots her.

CUT TO:

EXT. RUSSIAN BUTCHERS BACK ENTRANCE

The sounds of gunfire followed by screams and growls.

CUT TO:

EXT. BACK ALLEY

the Killer attacks the camera.

-END-

5

YOUNG AND NAIVE

"You should have known I'd find you again."
 Alex

With four segments shot it was now approaching the end of April and our fifth section was about to begin. This would be our halfway marker and in itself a milestone. Antoni McVay was to helm Young and Naive and would be shooting in Newcastle. A lot of the directors involved in Blaze of Gory have developed a working relationship with their actors and often cast the same people, I myself have done this and because of this project I am glad to have met and worked with so many actors and actresses that I most definitely will be asking them to join me on future endeavours, it was one of Antoni's regular cast, Juliette Strange, that I had hoped he cast but as it turns out she was unable to due to work commitments but to my pleasure she was later cast in one of the other segments.

Antoni went on to cast his segment including one of our producers, Dean Sills who went on to help spread the word of the project on the UK Horror Scene website by interviewing the Blaze directors and most of the cast. His help in promotion was amazing and I am told he will be including some of the interviews in his upcoming book. His Daughter even appears in the film, albeit as a photo of a dead body, during the filming of that sequence there was much hilarity as people entered the kitchen to discover the grisly scene.

Dean and UK Horror Scene have done a fantastic job of helping to promote this project and for that I am eternally grateful. It is people like them with a fondness and understanding of independent film that make our efforts feel worthwhile. That along with the fanbase we have developed via social networks and being featured in magazines, on tv and the radio has been heartwarming. I want to take a moment to thank you all for the support. Blaize and I cannot express our thanks enough.

Original Short Story 5:
Young and Naive, Old and Manipulative

She was only young, yet he longed for her love. Her innocence aroused him, and she knew it. She played with his mind, led him on, but all the time she did she didn't know how much power he had. He could control her with one word, the things he knew about her would be enough to bring her to her knees at his feet. He was manipulative and she was naïve, an unnerving combination. He knew just what to say to get her to do what he wanted and she thought she knew how to make him believe she loved him. In reality she hated him, for what he had, for who he had that she didn't. Her hatred had brewed from jealousy over many years because he had what she wanted and couldn't get. He yearned to be loved by the one person who would never love him.

She was beautiful beyond belief like baby girl in a mothers view for the first time. Her features were delicately placed on her rounded face with was as smooth as a babies bottom. Her shiny chocolate brown hair fell gently around her face without any effort. Her eyes were bright blue eyes were like a new born babies and her lips were peachy and plump. She was awfully slim with not many curves, her chest was quite flat and she wasn't particularly tall. Her best asset by far was her way with words, she could wrap anyone around her little fingers with just a few words, and she certainly didn't abstain from using it to the best of her ability. Her naivety sometimes got her into all sorts of trouble, but she was in the mind set that she could fight off anyone and anything and fend for herself. She knew she was gorgeous and she played on it. She knew that everyone looked at her wishing to be as pretty as her and she always let them know that they never would. She knew that people looked at her in awe like they would a new born baby in its brand new pram.

He was fierce like an angry dog, but at times he could be soft and gentle like a tiny puppy. His face was square with a slight softness to the edges. His deep green eyes were very wide like the sort you would expect to find on a tiny Pug dog. He had a short stubbly beard which never seemed to grow and it wasn't apparent that he regularly shaved. His hair was black, with a few flecks of middle age grey. It was short and spiked, often with too much gel in. He was very muscular and he was awfully

strong and he liked to let people know it. He used his strength to manipulate people and he often ravaged other people, like an aggravated dog. He longed to be a part of other peoples torment and he enjoyed seeing other people's pain. He could scare people with one glare and he could draw blood with one flick of the wrist. He had a very inviting aura when he wanted to get people close to him.

The way he saw things if he couldn't have someone or something then no-one could. He was the sort of person that always held grudges and would go out of his way to stop someone from living a gratified life. The way they met was rather unusual, not like you would usually expect. They didn't meet at a party, they didn't meet at work, they didn't meet on a night out; they met not in a fun or joyous atmosphere but in an atmosphere that was full of apprehension and affliction. The environment was not scintillating and ventilated but claustrophobic and lurid. The room they met in was filled with hatred and demise. The room they met in had blood covered walls and dilapidated furniture. The room they met in was not only precious to her but part of her whole life. She cherished the room and the people in it. The day they met was a day she would forever regret and a day he would forever remember.

The day they met was going to be her last day of freedom and his first day of absolute aesthetic pleasure. He knew right from the start that she was going to try and lead him on, she thought she could fool him with her beauty. Much to her disgust she knew he loved her and would never let out of his pathetic sight on any one occasion. The day they met was the start of something hideous and brutal that was only ever going to end erroneously.

She sat cross legged in the corner clasping her knees tightly to her chest. Uncontrollable tears ran down her baby like face like a fast flowing river crashing into a thousand broken souls. He was still ripping him apart right in front of her eyes like a dog attacking its newest victim. The walls were smeared with blood; everywhere she looked she could see part of him. If she closed her precious eyes she could picture him clearly, before he was gone, before he took him. All she could see was a blur of black through her bloodshot eyes. She stared at her bare legs which were covered in black dirt and smelt distinctly of fear. She couldn't bear to look up anymore the scene that played in front of her revolted her. The

only thing that mattered to her was being ripped to shreds and there was nothing she could do about it. She trembled at the thought of him turning around and looking her in the eye. All she could think about was how much he meant to her and how much she loved him, but he didn't love her back. Now he was gone, so was a part of her. Not having him in her life was going to be like a baby in a mothers' stomach with a ruptured placenta.

The torment in that room continued for days. To her those days seemed like weeks. But to him those days seemed merely like a few hours. He knew she couldn't bear to look at his body lying lifeless on the floor and there being nothing she could do about it, so he used it against her, used it to get her to do anything he wanted. The smell in the room got worse as each day passed – they say any human can smell death, even if they haven't smelt it before but no-one did- it filled the room and took over the fresh air. It was almost suffocating her; she thought she was never getting out. At times it amounted to so much that she wanted to bawl and scream 'mama' but she withheld herself from the embarrassment – she still had her pride. Everyday he stared her in the face and she just sat there helpless, unable to move, frozen from shock and dejection. He was valiant of his success to kill her soul, and make her feel like she had nothing. Just so that he could rebuild her hope and make her think he was the one who could make it all better. To her he was Satan and she was his Demon, she had to do what he wanted or she would live condemned and in squalor for the rest of eternity. She couldn't escape.

He had to wash the blood from his hands, which he often did on a regular basis. Hygiene was a big thing for him; he couldn't stand to have someone else's blood on his hands for too long. He had decided that he liked her and wanted to keep her locked away so nobody else could have her. He was going to make her believe that everything was okay, make her believe that every time he walked in the door everything was going to be okay he was going to be her best friend. Every time he thought of her his stomach dropped to the floor like when a dog wags its tail because it's being stroked. Today his face was clean shaven, just for today because he was going to clean her up and comfort her. He had spent hours pruning himself so he could go out and buy her some clothes; to make her feel beautiful for a while. He was in an ecstatic mood; he wasn't

really concentrating on what he was doing.

She had given up all hope of escaping, she just did what he said and got on with it. There were times when she thought things were going to get better but they never did. She felt like a no-one, he had taken her soul with him when he left the world. She didn't think she had anything to live for until that day when he was ecstatic. She sat cross legged in the corner as she did everyday; with no grace at all she just remained there without moving. The day she regained her soul was the day he would regret forever and she would relish the thought of getting away from him. He had a wash as usual, but he seemed in a better mood than usual, and as he left she noticed he had left the door open. That was when she decided then was her chance to get away from it all, to get away from hell. She dragged herself to her feet painfully but she didn't remain in an upright position for long, she crawled towards the door and checked that he had departed.

She couldn't get enough of the fresh air that filled her nostrils and the sunlight that dazzled her eyes; she didn't realise how much she had missed it. She took a few seconds to momentarily regain herself and she slowly got to her weakened feet that hadn't been used in months. She loved the feeling of the sand on her bare feet and then it dawned on her that she was no longer in her house which was where she thought she was, but she was in an old shack in the middle of no-where. At that moment she didn't care all she was thinking of was where she was headed all she knew was that she was headed away from here. Precisely at that moment she began to run, she stumbled, composed herself and ran as far and fast as she could away from the place she had been held hostage for months on end. She was free.

Her desk was cluttered, like a little child's room after a tiresome day of playing, and her drawers were overflowing with scraps of paper and unnecessary office tools. The in tray was piled so high she could barely see over. She felt like a child trying her hardest to get her head over the desk at a shop. She was used to it though, it never changed. After a short while of typing her next article she came to the realisation of what the date was. For her today was not a good day, all of the memories from three years ago came flooding back and no matter how hard she tried they wouldn't go away. No amount of psychotherapy or counselling could get

the anguish to disappear. Suddenly as if someone had come in and put everyone at gunpoint, every single person on the office stopped and gasped. She couldn't help but think what on earth had happened. Everybody was staring at her like she was centre stage. Then she noticed why. It felt like a glass of water had been tipped over her and left to dry on its own, except the water was warm, and slightly comforting. She glanced down in disgust only then realising what she had done. 'Not again' she thought. It always happened when she though about him, both of them. She felt like a baby, thought she should start wearing a nappy. It would probably stop the embarrassment. But it was too late now, all she could do was run, a feeling that was all too familiar to her and that she only ever had to do in these horrible situations. She couldn't believe she had done it again, she hated herself.

There are some things that happen in the past that torment you for the rest of your life, you can't help it, no-one can.

She ran out of the office building. She ran past the spectators. She ran past the traffic warden who was putting a ticket on her car. She just ran until she could run no more. Then she collapsed on the floor, it was tranquil here, she liked it. She stared contently at the sky like a baby would its mother; she lay there for hours watching the clouds roll by. The clouds just gently rolled on by without a care in the world and the sun shone brightly smiling at the world.

There was not a rain cloud in sight and any sign of bad weather inevitably ceased to exist. The sun reflected off the clouds making everything around them seem almost ultraviolet. The rays were clear as they spread through the sky and majestically swept any bad feelings out of the air. Just as everything seemed like it would be okay, a cloud of black seemed to engulf all of the beautiful pearly white clouds deep in its bowels. The sun seemed to cower in fear as the cloud edged ever so slightly nearer to it; its rays became non-existent and it had dimmed down entirely. It was as if the once luminous sun that appeared to have no fear had been confronted by the one thing it hated most.

At that moment as she watched the sun and the cloud fight it out she heard deep panting in her ear; dampening it with every outward breath. It sounded like an exhausted dog that had just finished a marathon.

Although it gave her a fright she did not open her eyes, she wanted to enjoy the peace a little longer. She felt a gentle tug on her silky hair, and fingers touch her delicate face. She became angry; whoever it was had ruined her peace. She did not enjoy having her face molested when she was trying to forget all of the bad things. She threw her arms up and whacked the 'object' that had ruined her moment of peace. Only then did she realise what, or who it was. Nothing could have prepared her for this, for him. All he did was stand there and watch her sit there knees to her chest like she did that same day three years ago. Her heart pumped the blood around her body so fast it felt like her veins were going to burst. His mind filled with evil intuitions and he smirked at her scrawny face. He loomed over her, as if trying to make her feel like she was lower than him in the hierarchy of life. She did not move, nor did she blink or even dare to breathe for those few moments that he watched her. How had he found her? She couldn't move; she was destabilised. She couldn't deal with this again, not now, not just as it was all starting to get better.

He was so pleased that all his efforts to find her again didn't fail him. He had finally sniffed her out. Found her, his true love, the only one he wanted to be with. Only it wasn't normal love it was more of an addiction. She was like a drug to him and he was dosed up to his eyeballs on her. He wanted her to know how he felt about her, he really did, but the way he wanted to show it was not normal at all. She wanted to steal her, he wanted her so nobody else was aloud her. That was how he saw it. That was it was going to be. She had no say in it. He was hers now. Forever. And there was nothing she could do about it. She could see that look in his eyes, the same look he had in his eyes when he was killing him, when part of her died. She knew at that moment that there was no way she was getting out of this one. She knew she was his now. Forever. She had to go with him, there was no point in her running; she wasn't going to try. When she got away before it was luck, she wouldn't get away now. Dead. That's what she was, her life ended right there, no point in living she was not going to have a proper life again. That was the day she became a walking corpse. The day the sun and the rain cloud fought. The day he found her again. The day he took her.

He gave her the sweetest smile. Took her by the hand and pulled her to her weakened feet. He put his arm round her tightly, too tightly, so she couldn't get away. She was his prisoner. She looked off into the

distance, at the corn swaying from side to side, masses of it swaying in unison contentedly, looking so cheerful with the sun setting smoothly in the background. Every step closer was a heart beat skipped, she feared for her almost non existent life. He still held her tight, still smiled, pleased with his stupendous achievement. He had won the race and she was his trophy, except he wasn't about to show her off to the world but lock her away, to have a life with her, just them on their own. Nobody was going to know where she was except him. Pleased, that's what he was. A monumental achievement. His father would be proud of him – for once – He was finally going to be accepted and she was finally his. There was no way she was getting away this time.

The room was algid, the same room, the memories that replayed in her head over and over would not cease. They wouldn't leave her alone. Kept on clinging to every cell in her disturbed brain and no amount of effort was going to get them out. They were there, stuck, evermore. She could still make out the faint stains on the walls from the blood that had once covered them. Every time she looked at the area where he lay on that fateful evening, she could see him laying there helpless. Every night when she eventually fell asleep she always awoke moments after as a result of the terrible dreams she would have. Nothing could make them go away. Every day he would bring her food, water and clothes, like a dog returning a stick thrown by its owner. She didn't understand what he wanted from her; after all she was only human. There was nothing special about her.

Behind the Naivety:
The Making of Young And Naive

Being at the halfway point in the overall production stage gave all the cast and crew a feel of accomplishment and excitement and spirits were high. Each film had a different style and now it was the time for Antoni McVay to showcase his style. I encountered Antoni when I was showcasing short films as part of a monthly DVD show I created for a horror magazine. I enjoyed the home video style of his film 'She', a quality he brought forward in to this segment, enhancing a voyeuristic stalker element. This segment also has flashbacks and distorted memories that added an almost Hitchcock-ian element to the screenplay.

Antoni's lead cast were perfectly chosen, Ashleigh plays a convincing victim and Simon's Alex is a very disturbing psychopath, he does an exceedingly good portrayal of a deranged nut-bag, i'll remember to be weary of him when next we meet.

During this segment it was required for the killer to have a murder log book. Antoni took on the task of creating the book himself, the book would be heavily featured within this segment so each page had to be different and Antoni began on a laborious task of compiling images and cutting and pasting of headlines to add to the belief of characters demented state

Luckily it had no effect upon the director.

Call Sheet Blaze of Gory: Young and Naive

Date 20/07/13

SUNRISE is 04:55AM, SUNSET is 21:29PM

CALL TIME: Arrive 10:10 and Ready to shoot 10:30AM – Everyone (except Ashleigh)

LOCATION: Studios, Floor 3 (postcode will be text to all people)

Antoni and Lee will arrive before this to drop off equipment, etc.

CALL TIME ASHLEIGH: 12:00

10:45:00	PICK UPS – Office and Scrap book imagery
12:00:00	Main drama in the scene, including our lead actress. Ashleigh's dress might be too bloody to use. (be prepared to disguise)
13:00:00	We will film the start of scene 22 (which is being rewritten so it happens in the office location.) No blood or make-up will be required yet.
13:30:00	Kat or Elena will start work on putting make-up on our extras. Antoni will film a scene with Simon killing Dean in a back alley.
14:30:00	Film the end of scene 22. This is a dream sequence with lots of extras.
15:30:00	Establishing shot Corine leaves her work building. Ashleigh's dress is stained, we will attempt to do this from a distance and we will cover up the stains with her jacket.
16:00:00	Additional footage for scene 11.
16:45:00	Make-up will be needed on Ashleigh to match what she had at the end of scene 12's previous shoot.
17:00:00	The end of scene 12 will be filmed in the garage.
18:00:00	Scene 19. We will film Corine as she is about to escape. Corine finds Alex's scrap book, then she turns around and hits him with an axe.
19:00:00	Scene 21. (must show Corine leave the building)

Our plan is to finish by 21:00 at the latest. Should we be ahead of schedule then we will finish earlier.\

Also note that we will film a final shot of Simon with the face prosthetic on on the 21st of July (after the Summer's Night shoot.)

Young and Naive
Shooting Script

Directed by Antoni McVay
Screenplay by David V G Davies
Additional writing by Antoni McVay

Corine	Ashleigh Gloyne	Scrapbook Victims
Alex	Simon Craig	
John	Antoni McVay	Catherine Motreanu, Sandra Veronica
Sleazy Co-Worker	Dean Sills	Stanczyk, Lisa Booth, Blaize-Alix Szanto,
Friendly Co-Worker	Steve Pollard	Toria Swales, Vicky Shields, Natalie Roe,
Co-Worker 1	Ratisha Belush	Sara Hardeland, Emma Gordon,
Co-Worker 2	Bradley James Hal	Beth Shimmin, Anna Bennett Squire,
Co-Worker 3	James Hogg	Rebecca Sills, Francesca Lean,
Co-Worker 4	Elena Verrall	Max Gee, Emma McBryde
Co-Worker 5	Ruth Norman	Amelia Elton, Amanda Tall,
Michelle	Derrin Atkins	Carly Louise Simpson
Rose	Laura Million	
Jennifer	Gemmie Ter-berg	
Corine's Friend	Kirsty McClure	
Football guy 1	Stuart White	
Football guy 2	James Regan	

Producer	Antoni McVay	Production assistants	Ruth Norman
First AD	Lee Bibby		Stephen Thomas
DOP/ Cinematographer	David Mordey	Grip	Stephen Thomas
Cinematographers	Lee Bibby	Stills Photography	Kayla Wren
	Ian Lawlor		David Mordey
	Simon Craig	Make up	Natalie Roe
	Antoni McVay		Sara Rose Dickson
2nd Unit	Lisa Booth		Elena Verrall
Cinematography	James Hogg	Location Scout	Kaitlyn Scott-Good
			Lee Bibby
Editor	Antoni McVay	Props	Simon Craig
Composer	Synoiz		Antoni McVay
Production assistant/Clapper	Heather Crisp		David V G Davies
Sound recordist	Emma Gordon		

Thanks to
John Shelton and Lynn McVay

Shot on Location in
Newcastle, England, UK

EXT. PARK

A couple of guys are playing ball in the park, GUY#1 kicks the ball at GUY#2 who misses it. the ball heads towards CORINE (She was beautiful Her features were delicately placed. Her hair fell gently around her face without any effort. Her bright blue eyes were like a new born babies and her lips were peachy and plump. She was awfully slim with not many curves, her chest was quite flat and she wasn't particularly tall) is sitting cross legged on the grass reading a book. she doesn't flinch as it stops right by her feet, GUY#2 runs up and bends down to pick up the ball he stops mid bend and looks at her, she looks up and gives him a half smile he picks up his ball and walks back to his mate with a shocked looks on his face and making hand gestures so that his mate notices the girl and how attractive she is through binoculars someone is watching CORINE, she gets up and walks away but she has left something on the floor, GUY#2 runs in, picks it up and goes to give it to her.

Close up of bushes, someone (ALEX) is in there watching her but we cannot see who.

EXT. STREET

From a distance through a camera in high zoom almost pixelated as CORINE goes to enter a shop/building GUY#3 holds open the door for her and watches her enter GUY#4 exits the building and looks back at her.

EXT. BUSHES

ALEX puts his camera in his bag and pulls out a scrapbook logging in it the time and location of that the girl is doing.

INT. ROOM

The notebook is placed on a shelf filled with similar notebooks and countless surveillance photos of Corine ALEX sits in front of the shelf and looks at his hand projected on his hand are images of her (using a video projector) from behind him we hear the sound of a zip then his arm begins to move suggesting he is masturbating.

His head leans back as the wall changes (post production fx) with images of her coming to life

EXT. GARDEN FANTASY

She sits in a beer garden wearing a sexy summer dress, the shoulder strap occasionally falling off her shoulder, she is not wearing a bra, but not in a sleazy manner. several men are standing around her watching her every move, when she adjusts her strap they pause drinking. a BARMAN enters the frame with a new Delboy Trotter style drink, he places it down beside her pointing at a MAN in the far corner, she looks over at him and tipping her sunglasses mouth the words thanks he raises his glass to her. she leans back and stretches and all the guys are almost at the edge of their seats looking at her one is even fanning her with a big leaf. she begins to apply tanning lotion to her arms . pan around the men all standing around her she is now laying on her front topless reading a book , the men are now sitting around her glued to her every move.

INT. HOME GYM

ALEX works out, the tasks seem effortless to him, his body is a machine. taped to the wall are surveillance photos of Corine

EXT. STREET

ALEX watches as CORINE exits her work and walks down the street.

creepy shots as he follows her. suddenly JOHN rushes past ALEX and taps CORINE on the shoulder, she turns, ALEX not sure what to do, almost stops in his tracks shocked.

JOHN
Hey CORINE. You forgot this

He hands her a document.

CROSS FADE:

CORINE
Ah brilliant,

ALEX turns away and steps to the wall, he continues to look at CORINE and nervously tries to looks inconspicuous.

CORINE
Thanks John

JOHN
So what are you up to tonight?

CORINE
Ah nothing really just chilling out

JOHN
You fancy getting a drink with me?

CORINE looks at him and motions to say something.

JOHN
It's OK, you don't have to, I just thought we could you know...

CORINE
Nah, it's just I did just want to chill out tonight.
(pause)
how about Friday?

ALEX looks on, he is getting angry but still

trying to not be seen he remains hiding towards the wall.

JOHN leans in and says something in her ear making her laugh, she then gives him a phone number and they brush hands.

This touch means the end of the world to ALEX. flash cuts of JOHN's face followed by an angry ALEX.

EXT. STREET

Shot from the far side of the road ALEX sits by a wall the road in front of him has cars passing every so often he is shining an apple, spending a great deal of time over getting it just perfect. He takes a bite and the juice rolls down his bearded face. He wipes his face on his sleeve and then reaches in to his pocket pulling out a dog biscuit. He then leans forward and waves the dog biscuit to camera.

Show a close up of a dog its head rises as it sees the biscuit, it then stands close up of his smiling face as car screech, thud, yelp, scream.

CUT TO:

EXT. STREET

SOUND FX

FADE TO BLACK:

ALEX watches as CORINE exits her work and walks away down the road.
Creepy shots of him following without her knowledge. she turns down an alleyway he gets closer to her then he is no longer behind her as she turns hearing a noise. she returns her attention to the direction she is headed and

BLAM
He is there

CUT TO BLACK:
INT. ROOM

She sat cross legged in the corner clasping her knees tightly to her chest. Uncontrollable tears ran down her baby like face right in front of her is ALEX, he is ripping in to the body of JOHN. There are pieces of him everywhere. She looks down at her legs as they get splattered with blood. She closes her eyes tight montage of shots of JOHN alive and now dead. ALEX emerges from his maniacal shredding of John and gets in close to CORINE's face, he leans in more, she is really crying, he licks her face.

CUT TO BLACK:

PASSAGE OF TIME:

Although he doesn't hurt her the emotional distress she encounters at his hands.

INT. WASH ROOM

Close up of the sink He washes his hands with extreme precision. his OCD taking over Excessive scrubbing as the blood washes away, his hands are now clean but he continues to wash them close up of his face as he concentrates Close up of him looking in the mirror, he looks off camera towards where he is keeping CORINE then back to the mirror, he reaches up and strokes his unkempt beard then his eyebrow raises he looks back at the door and his stomach rumbles whipping his attention back to himself.

INT. ROOM

He enters the room not fully closing the door as he seems happier than before yet still very little emotion on his face, a face that is now clean shaven / sporting a designer beard. in his hand he is holding a bag of clothes, he drops the bag at her side and leans down unlocking the shackle around her foot. He gets his chair and

sits again two feet in front of her, motioning with his hand for her to look inside the bag she gingerly reaches out and grabs the bag and pulls out the contents inside the bag are a new set of clothes for her again he motions for, this time for her to change from behind him she staggers to her feet and manages to fully stand upright for the first time in a while, she almost falls as the pain of standing overwhelms her she puts her hand out to steady herself. Her hand on the dirty wall.

Shot from behind her (so she is out of focus as he watches her strip down and then put on the new clothes.
Close up of her face as she finishes dressing, her face look very sad, she wont look at him just slightly to the left and down.

The man turns his finger to tell her she needs to turn around so he can see her wearing new outfit. he motions for her to sit she follows his instruction and sits back down and brings her knees back up to her chest.
He stands and turns away her eyes quickly spot the fact he hasn't re shackled her foot a moment of life sparks in her eyes but then her eyes dark back to him, she is putting his chair back in the corner of the room then he leaves the room.

Off camera sound as he again washes his hands.

INT. WASHROOM

He is scrubbing away, behind him the door is ajar and in the distance we see her move.

INT. ROOM

She dragged herself to her feet and tentatively moves toward the main door, the sound of him scrubbing continues as she moves more and more towards the door.

INT. WASHROOM

He is still scrubbing his hands.

INT. ROOM

She is at the door and pulls it open and inhales the fresh air.

EXT. BEACH FLASHBACK IN CORINE'S MIND

Her foot steps from the concrete to the grass. pan up, CORINE is wearing a summer dress, her makeup perfect, a big smile upon her face . her bare feet begin to make fists with her toes she leans back with her arms outstretched her head back embracing the sun on her face.

She steps forward skipping/dancing

EXT. SHACK REALITY

Crash zoom to her face, she is standing outside the shack, she looks from side to side almost squinting then, in a heartbeat she begins to run. She runs and runs as fast as she can, getting cut by tree branches and almost stumbling she makes it to a road, she reaches down and touches the hard tarmac.

> **CORINE**
> (Sigh)

TITLE CARD: 3 YEARS LATER

INT. OFFICE

> SLOW FADE TO WHITE:

CORINE, now dressed in a work suit is sitting at her desk, her head in her hands she jumps awake as her elbow falls from the desk.

FEMALE COWORKER 1
Hey, you OK?

CORINE just nods and returns to her computer screen High angle of Corine sitting at her desk, high piles of paperwork dominate the shot.
Close ups of her typing close up of the screen as she types the date flash edits high contrast of her face and flashbacks of her time incarcerated at the hands of the madman. Looking over to her pin board she notices the business card of her psychotherapist she clenches her eyes tight, tighter, her 3 coworkers are all looking at her she looks at them each in turn, at their shocked and disgusted faces, close up of her confused face. She then looks down we see she has wet herself, a puddle has formed at the base of her chair. Close up of her distraught face.

BIG WHITE FLASH

She stands bolt upright knocking paperwork off of her desk.

EXT. CITY STREETS

With a camera rig looking back to her she runs out of the building, She just runs until she could run no more.
Various cuts at convenient slots.

EXT. PARK

She enters frame, tired and out of breath, she bends over to catch her breath then sits on the ground, eventually laying down on her back.

EXT. SKY CORINE'S POV

The sky changes over time lapse from clear to over cast. using a sinister effect in post production to indicate the sky has become evil

EXT. PARK

Close up of her face as she lays on the ground with her eyes closed, sound of heavy breathing (not hers) causes her to frown, the breath is close enough to move her hair. Then her hair is tugged and she shifts her head accordingly frowning more intensely. A hand enters frame and brushes her hair lovingly, on the second attempt to brush, she smacks the hand away and opens her eyes looking directly at the camera she is startled and tries to scream.

CUT TO BLACK:

INT. ROOM

Slow track back from him as he stands there looking directly at the camera still wearing the same outfit as before but his beard has grown back.
Reverse angle at Corine sitting there, her knees clutched to her chest, her work suit torn in places.

> **ALEX**
> (off camera)
> You shouldn't have left me.

She tries to look even more away from him.

> **ALEX**
> (off camera)
> You should have known I'd find you again.

Close up of his face as he smirks and steps forward close up as he looms over her he then grabs her pulling her to her feet, she tries to be limp and not fight him, she is terrified. he sniffs her hair deeply He puts his arm round her tightly, too tightly, so she cant get away. She was his prisoner. She looked off into the distance, at the door, now bolted shut to the window, now boarded up her eyes dart around the room, insert images of JOHN being tortured he

lets go and leaves the room.

FADE:

INT. ROOM

He returns with breakfast, places it down by her feet and leaves the room.

FADE:

INT. ROOM

She is falling asleep, she drifts away then wakes up violently. He is sitting on a chair in front of her drinking a hot chocolate slow 2shot track out.

FADE:

He is standing at the door and slowly moves towards her, he looks a bit older and she has a few more amenities around her but is still chained he sits next to her and hugs her she look completely different, the life has gone she is still alive but her soul is no more.

-END-

6

SICK LITTLE BOY

"I'm not a retard! Mummy says I'm special"
<div align="right">Toby</div>

Original Short Story 6: Sick Little Boy (Opening Only)

Blaize's Notes

This is only the introduction for the story, but the idea is that the little boy, maybe 10 or 11 years old loves model airplanes (the creations). He is a sociopath and they are the only things that calm him down, otherwise he is unstoppable in the sense that when he is angry there is no telling what will happen.

He ends up killing his family. He hits his brother around the head with one of his planes because he broke his favourite one. Then he shoves the broken parts down his brothers' throat and rapes him while he is still alive and then he chokes and suffocates on the plane parts. This happens in the room that they share. Then the boy goes downstairs and he asks his dad for some crisps, his dad says no so he stabs his dad to death. And finally his mum, he pushes her head in a boiling pot of water (one of the big metal lobster boiling pots).

The sun glimmered through the beautiful Georgian window and lit up everything in its path, leaving only one corner untouched. The room was warm, and a slight hint of moisture licked the air, the little specks of it glistening in the sunlight. A slight whir entered the room as an old car rolled past the slightly opened window. The aura in the room was quaint, almost sincere. In the only corner of the room that was not lit up, sat a boy, who was no older than 12. He was quite contented; sitting cross legged, assessing an object on the floor very precisely from every angle. His eyes glinted as they caught small flecks of sunlight; he batted the light away as if it was that easy. He smiled in awe at the creation that lay on the floor in front of him. A small smile slid across his face as he traced his fingers gently along it. He gently picked it up and walked across the room, dodging as much sunlight as he possibly could. With his creation in one hand, he pulled open the closet door to reveal a whole room full of creations.

These creations were bewildering, big ones, little ones, elaborate ones and simple ones. But one thing was for sure he loved them all.

There wasn't one day that went by that he didn't wonder at them, stare at them. He loved them too much to even go for one day without seeing them or building them.

Beyond the Sickness:
The Making of Sick Little Boy

Director Simon P Edwards made contact when the project was in its pre production and expressed interest in directing one of the segments, there were at the time, three segments without someone at the helm. Looking over Simon's body of work, I felt his talents of exploring sinister undertones would be perfect for the thriller element of Sick Little Boy.

Blaize, Simon and myself all agreed that the original short story was problematic due to the inclusion of two 10 year old boys and the scenarios that they were to engage in. Obviously this was one of the more disturbing elements to one of her stories but Blaize was in agreement that this element would need to be changed in order for it to actually be able to brought to the screen. We developed the idea that Toby was mentally challenged and had a split personality disorder, thusly the two 10 year olds becoming one character. With this in place, the performance was going to be a very demanding one, not just on the actor but also on how the film was to be shot.

As a list of possible research films I suggested to Simon that he check out the films Raising Cain and The Lord Of The Rings films as examples of how it could be possible to have one actor interact with

himself. Casting the lead role was a daunting task as essentially the actor would be performing two roles. Oliver Malam was a phenomenal choice, he definitely owns each shot he is in, managing to create two characters very well. He is definitely a talent to keep an eye on, Simon has since gone on to cast Oliver in his latest film, Six Hot Chicks in a Warehouse.

In order for the film to begin a shooting schedule was put in place but was reliant on the footage for Toby's screen. This was the first to be shot and was all down to the availability of the actress from the States.

A second hurdle tripped us up three days before filming of the main shoot was to begin, when one member of the cast, a bit part actress from the HBO series Game Of Thrones, dropped out unexpectedly for another project, Simon and I were annoyed at this as things were all running smoothly, locations and people booked, but luckily, I managed to find a last minute replacement who leapt at the chance, jumped on a train to Norfolk and performed the role, salvaging the film.

During the editing process, Simon felt that something was amiss and was concerned that the there was an element of dread missing from his segment. After analysing the script again, he felt he could reshoot two key scenes with a heightened element of dread that would add a vastly more sinister undertone that would make the film ten times better. Nervous that this would delay the overall project Simon hesitantly contacted me with his proposal. I instantly agreed, telling him that if he wasn't happy, then neither was I and what could I do to help. Simon was

thrilled I was open to this and arrangements were underway. Sadly our actress wasn't available to do a re shoot and again we needed to recast, this time the role went to Carly Watts who just so happened to be the directors first choice for the role but wasn't available previously, she agreed to the part and the partial re shoot began. I was invited to the re shoot and provided the new gore sequence as the original FX artist was also sadly unavailable.

This is often the case with pick ups, especially when all of the crew have lives and jobs. Luckily the re shoot went swimmingly and the overall feel of the segment was improved.

> *"It's probably the least goriest of the stories, but hopefully the darkest"*

Simon P Edwards - Director

Sick Little Boy
Shooting script

Directed by Simon P Edwards
Screenplay by David V G Davies
Additional writing by Simon P Edwards

Clara	Carley Watts	First AD	Danny Cotton
Dad	Mark Ivan Benfield	Cinematographers	Danny Cotton
Toby	Oliver Malam		Sam Hoggarth
Mama	Elle Alexandra		Tom Lloyd
		Production assistant	Lee Hampton
		Sound Recordist	Scott Newstead
		Make up	Juliana Ratcliff
		Prosthetics	David V G Davies
		Editor	Simon P Edwards

Thanks to
Jenny Miller, Dianne Fonseka, Renny Fonseka and Amy Yaxley

Shot on location in
Norwich, England, UK

INT. HOUSE — DAY

The sun cuts through the curtains and lights up particles of dust in the air. the camera pans the room, it's a well kept room with strong bold furniture track through the doorway and up the stairs the camera halts outside a bedroom door. on the door is a crude childish drawing of a plane and a plaque with the name TOBY on it.

The camera turns to look down the stairs as MUM ascends with a tray, on the tray is a juice box, some sandwiches with the crusts cut off and an orange.

An extremely attractive woman in her twenties is wearing an extremely sexually provocative outfit which could almost be seen as inappropriate for a Mother figure. She looks tired and put out. she stops in front of the door and knocks.

> **MUM**
> Toby, your father asked me to
> bring a snack for you... can i
> come in?

> **TOBY**
> (off camera and almost
> indecipherable)
> EEAAAHH

MUM opens the door and steps into the darkness.

INT. TOBY'S ROOM

It is dark inside the room with very little light coming from an off camera light source, the camera pans the room, from the limited light source there are several toy planes hanging from the ceiling, the bed sheets also have pictures of planes. the camera ends on a desk, upon which is a lamp, this is the only light source. on the desk is a collection of Air-fix model kit boxes and a collection of hobby paints and brushes, the

mum moves the empty kit box and places on the desk the tray. she steps towards the person sitting at the desk and fills the frame allowing for a cut shot from the other side of the desk we see the MUM uneasily place her hand on the shoulder of TOBY, he is a young man in his mid to late 30's.

He is autistic slightly overweight and sitting in a wheeled office chair. He is concentrating on gluing parts of his model and his face is distorted by the placement of a large magnifying glass.

He does not acknowledge the touch of his younger step mother and does not notice the snacks placed to his left.

Show the MUM looking down at her son as he concentrates on his project.
She tussles his hair and he tries to move away from her in disgust. She sighs and leaves the room closing the door as she does so. Toby now centre frame concentrates on his plane.

Reposition the camera to see TOBY at his desk and another FAKE TOBY, his manifestation of himself, sitting on his bed.

 FAKE TOBY
 (off camera)
 You're doing it all wrong

Toby grumbles.

 FAKE TOBY
 (off camera)
 It's upside down

 TOBY
Go away.

FAKE TOBY
(off camera)
It will look stupid

TOBY tries to cover what he is doing from anyone who might be behind him.

FAKE TOBY
No, you're gonna mess it up.

TOBY
No I'm not

FAKE TOBY
(off camera)
Haha you idiot Toby.

TOBY
(angrily)
Go AWAY

FAKE TOBY
(sticks his tongue out at toby)
Retard

Close up of TOBY, he slams down his fist in anger and turns to the bed throwing a piece of his plane, but FAKE TOBY is not there, he is now at the door, he gives TOBY the finger and again sticks his tongue out before leaving the room closing the door.

TOBY's realization that he threw piece of his plane angers him, he wheels his chair to the bed and looks for the piece, he finds it a smile forms on his face.
TOBY returns to his desk and opens up his laptop. On screen is a naked woman. She speaks to Toby.

MAMA
Are you being a bad boy Toby?

She touches herself intimately. Toby's eyes are transfixed on the screen.

TOBY
Mama I'm a good boy. It's him that's not...

Toby turns round and looks away from screen.

MAMA
Well you tell him that if he doesn't behave his mummy will spank him.

Toby turns around again before looking at the screen again.

TOBY
He says you shouldn't be mean.

The woman takes off her panties and rubs them between her thighs before holding them up to her face.

MAMA
You tell him that he can do as his mama tells him... or he doesn't get these.

FAKE TOBY is sat at the foot of the bed. Close up of his face.

FAKE TOBY
fuck you

INT. DOWNSTAIRS HALLWAY

A doorbell sound brings MUM to the door, she opens it to reveal DAD, she kisses him on the cheek to welcome him home as he grabs her backside. He places his coat on the hook near the bottom of the stairs and as he follows his wife off camera we see FAKE TOBY sitting at the top of the stairs staring down at his step mum and dad.

 DAD
 (not looking up the stairs)
 Hey son, good day?

INT. TOBY'S ROOM

TOBY's attention shifts to the door.

 TOBY
 Dad?

FAKE TOBY reenters the room with a pair of panties, he is waving them about on his finger.

 TOBY
 What are you doing with those? Go
 away

 FAKE TOBY
 No, this is my room as well, I
 have as much right to be here as
 you. As for these?

Holding the panties right up to TOBY's face.

 FAKE TOBY
 Don't you want them

He takes them away from TOBY's face and puts them to his own and inhales deeply

 FAKE TOBY
 hmmmm you gotta love that smell

Again he places them too close to TOBY's face TOBY tries to back away from it

 TOBY
 Mummy's gonna be mad. Put them back

 FAKE TOBY
 Bollocks

He wheels Toby to the bed and pushes him out.

> **TOBY**
> It's not right! Don't do it

FAKE TOBY pulls down TOBY's trousers exposing his bottom close up of TOBY's face as one hand holds his head to the pillow so he is facing the camera, another hand hold the panties against his nose. his body jerks back and forth as if he is being raped by FAKE TOBY

INT. KITCHEN

DAD is sitting at a table with a newspaper, MUM has her back to him at the kettle, she pours out two coffees and turns back to him placing a cup right in front of him leaning forward with her breasts almost falling out of her top.
She leans back and picks up her cup as a thud is heard from upstairs.
DAD looks up.

> **DAD**
> What the hell is going on up there?

MUM places her coffee mug back on the counter.

> **MUM**
> (reluctant)
> I'll go see

DAD grabs her arm as she goes to pass him and she stops in her tracks, she bends down to kiss him.

> **DAD**
> It's OK, I'll go, but stay
> as you are a second.

DAD stands up, takes a couple of steps and looks at his young trophy wife's backside bent over the table. He gives her light slap on the butt and looks back as he exits the room.
MUM takes a sip from her coffee and looks up at the ceiling.

Her eyes look empty.

INT. TOBY'S ROOM

Close up FAKE TOBY's face as it expresses sadistic pleasure.

CUT TO:

INT. DOWNSTAIRS HALLWAY

DAD begins to ascend the stairs.

CUT TO:

INT. TOBY'S ROOM

Close up of TOBY's face as off camera FAKE TOBY thrusts.

CUT TO:

INT. UPSTAIRS LANDING

DAD knocks the door of TOBY's room.

> **DAD**
> hey buddy, you OK in there

> **TOBY**
> (off camera)
> DON'T!

Dad opens the door

> **FAKE TOBY**
> (off camera)
> I said don't you mother fucker

Something slams the door shut in DAD's face

CUT TO:

INT. TOBY'S ROOM

Close up of TOBY looking up over his shoulder he looks shocked FAKE TOBY looking at the door.

FAKE TOBY

Cunt

FAKE TOBY looks back down at TOBY and spits close up on TOBY as he begins to Cry.

TOBY
(whimpering)
Dad!

TOBY half naked face down on the bed, his bare arse exposed his right hand is hidden from view and his left hand is holding his step mother's panties by his face begin to track back as he cries.

INT. UPSTAIRS LANDING

DAD begins to descend the stairs as behind him FAKE TOBY runs out of the room in to the bathroom DAD spins around to see but FAKE TOBY has gone, seeing that TOBY's door is open DAD steps forward to investigate.

INT. TOBY'S ROOM

DAD steps in and discovers TOBY on his bed pulling his trousers up, DAD notices the panties and snatches them

DAD
You sick fucking retard! What the fuck!

CUT TO:

TOBY
(stuttering)
b-b-b-b DAD it w-w-w

DAD
Enough, I shouldn't have yelled at you, I'm sorry but you mustn't do things like this, its wrong.

TOBY
But DAD

DAD
Forget it, get some sleep and this never happened OK?

He takes the panties and leaves the room.

TOBY
Dad, please

But DAD has already left and standing at the door is FAKE TOBY.

FAKE TOBY
He never listens to you and do you want to know why? he despises you

TOBY
No he doesn't

FAKE TOBY
He called you a FUCKING RETARD! are you going to let him get away with that?
(TO HIMSELF)
I sure as hell wouldn't

TOBY
He didn't mean it

FAKE TOBY
Bollocks! He hates you

TOBY
No he doesn't

FAKE TOBY
Fuck him man

FAKE TOBY then laughs at him knocks over a toy plane

> **TOBY**
> (whining)
> Why?
>> **FAKE TOBY**
>> Don't worry I'll sort it

He leaves the room

INT. KITCHEN

Dad enters the room
> **MUM**
> Are you ok?
>> **DAD**
>> Yeah, just...

> **MUM**
> Just what?

>> **DAD**
>> We may need to think about getting him more help, away from here... away from you.

> **MUM**
> But he's never been away from here

INT. HALLWAY

FAKE TOBY looking in to the kitchen

> **DAD**
> Exactly.. maybe we should

>> **MUM**
>> NO, shouldn't he stay here. I mean wouldn't it be lonely just us two? what did he do that's so bad?

INT. KITCHEN

The two stand around the table with the doorway in the background.

DAD
That doesn't matter and you're
not listening, I'm not saying we
send him away I'm just saying
perhaps he needs some help away
from here. would give us more
quality time together.

Dad leans in close to step-mum and gives a smile. the door in the background shuts causing the discussion to halt and they both looks at the door. MUM puts her coffee mug in the sink and goes to leave the room.

MUM
Ee don't want to go rushing into
any big decisions, he is your
little boy after all. I'm gonna
take a shower and go to bed. I
suggest you have a serious think
about it honey.

She passes him, her butt swaying in the tight outfit as dad leers)

MUM
Come up when you're ready

MUM leaves the room and closes the door behind her DAD looks at the door then sits back down putting his head in his hands.

INT. STAIRCASE

MUM ascends the staircase, she is on her cell phone to a friend.

MUM
I can't believe it Barbara. I
know he has a valid point, I once
thought it myself but Toby, he's
harmless. I'm used to him now, oh
hang on a second

MUM moves to TOBY's room

> **MUM**
> (taking the phone away from
> her ear)
> TOBY?
> (she knocks on the door,)
> TOBY... honey... are you ok?

She attempts to open the door

> **DAD**
> (from downstairs calling up)
> Leave him be he's sulking

MUM lets go of the handle and returns to her conversation.

> **MUM**
> Sorry about that, but seriously
> I don't know what to do, he's a
> special boy, it would make
> things very different if he
> wasn't here. Anyway, never mind
> I'll speak more to you about it
> tomorrow at lunch yeah?

She ends the call and enters the bathroom.

INT. KITCHEN

DAD now standing at the sink, both his hands on the side as he leans over his head down. The door creaks open but he doesn't hear it. a hand reaches out and grabs a knife from a rack DAD rubs the back of his head as he thinks about what he's been saying. a noise makes him spin around only to get stabbed hundreds of times (we never see the killer).

> **TOBY**
> (off camera)
> I'm not a retard, mummy says
> I'm special

Mirror the shot of blood spilling in to the sink and going down the drain.

CROSSFADE:

INT. BATHROOM

With the water from the shower going down the drain. Close up of MUM's face as the water cascades on to her.

INT. UPSTAIRS LANDING

Right outside the door of the bathroom as a bloodied hand is placed on the door and pushes it open, in the background MUM can be seen in the shower cubicle.

INT. BATHROOM

The curtain is ripped out of the way by TOBY, MUM stands there shocked and covers herself as best as she can with her hands.

 MUM
 Tob...

She gets cut off as she looks at her bloodied son, she then grabs him checking to see if he is ok.

 MUM
 Hun are you ok, what happened?

 TOBY
 Do you love me mummy

 MUM
 (scared and confused)
 Of course I love you b-b...

Before she can finish her sentence he grabs her, pulls her out of the shower and throws her against the floor he gets on top of her.

TOBY
I love you mummy

TOBY/FAKE TOBY
love me mummy ...
(he forces himself on her)
... fuck me mummy

He grabs her hair and slams it down on the tiles floor and rapes her while the knife is at her throat He begins to cry and then gets angry at himself, he lets go of the knife and begins to punch himself in the side of the head, MUM regains consciousness and tries to push him off but he pound on her chest in an angry ape fashion. he then finishes his act picks up his step mother and places her in the bath.

TOBY
you wanted to get rid of me all I wanted was you to love me. fuck you mummy

He urinates on her.

EXT. HOUSE

TOBY exits the house for what may be the first ever time he squints in awe of the outside world, drops to his knees and then slits his own throat.

-END-

7

MASQUE OF THE RED RAPE

"How many do I have to kill before you STOP!"
 Man

Original Short Story 7:
Untitled
(Synopsis only)

A man has lost all of his family, everything that ever meant anything to him and is now all alone. Because of this he goes insane and he goes around brutally raping any living thing that he can get his hands on. He wears a ripped balaclava and a huge leather trench coat. One woman that he rapes, he takes home and keeps her captive. He tortures her in the worst ways possible. He rips out her hair, rips off her nails. She keeps screaming 'Oh God' 'God Save Me' and he screams 'There is no god I learned that the hard way' and then proceeds to carve crosses into her skin and then burn them. All this while he is pleasuring himself and making her pleasure him too. He suffers from voices in his head and right at the end he skins her alive and he watches her slowly die. He receives final instruction from the voices and as he lovingly caresses her body he shoots himself.

Producer Notes to Blaize

This is definitely your goriest idea. I like that you mentioned that french film in your notes and I think that element will be the toughest part of the film, I've got a director in mind and he is very clever at creative interpretation, he's based in the states so we cant have a sit down meeting with him but I'll set up a group chat online and we can brainstorm this one and see what becomes of it during the script writing

Behind the Mask:
The Making of Masque of the Red Rape

This is one of the more graphic stories that emerged from the mind of Blaize, I was concerned as to how this would be brought to the screen but I knew that Rob would do an amazing job, I wanted Rob from the start and I knew some of his regular casting choices, so I was very excited when he informed me that Damien Colletti would be on board. He's an actor with great diversity and I was eager to see him in this demented role, he definitely pushed himself and delivered a great performance, as did Vania a very difficult role to undertake and again the delivery was awesome.

Rob's vision took away the 'in your face' extreme scenes and focused on the mind of the character, something that I felt made the chapter far more sinister. He focused on the element of the synopsis where it states the man **'suffers from voices in his head'**. This is definitely a dark story and the exploration of a mind on the fine line between fantasy and reality is a amazing addition to the diversity of films in this anthology.

Robert chose to shoot the film as if a video diary hosted by the protagonist so utilised a static camera with inserts of a madman, who is possibly a figment of the Mans imagination. The madman was expertly portrayed by the director in an improvised performance.

> ***"One of my bad habits is I will allow actors to improvise allowing a natural flow"***

Robbert Noel Gifford - Director

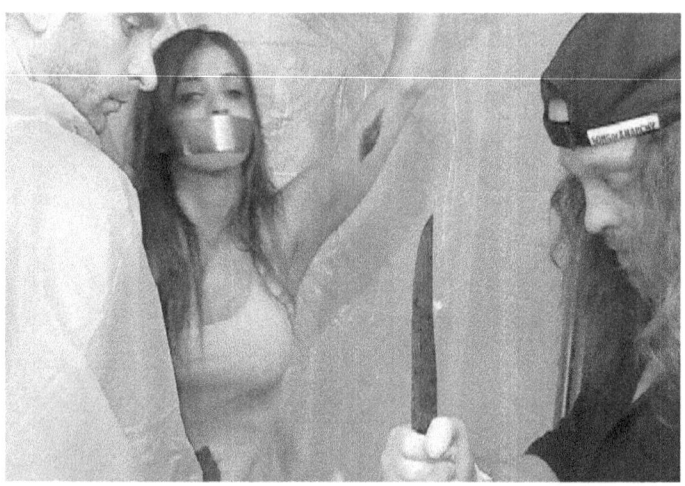

Watching this segment back I can picture it being in black and white film lie an episode from the original Twilight Zone or Outer Limits, or perhaps even a stage play, the possibilities of this story were very open to development and Robert has done an incredible job, I definitely want to work with Robert in the future, I am a fan of his work and hope that this film will help widen his audience and bring more awareness to his art. The Project at this stage was definitely taking on good shape and I was eager to assist the other film makers as much as possible in brining their segments to completion.

Masque of the Red Rape
Shooting Script

a Film by Robert Noel Gifford

 Woman Vania Bezerra
 Man Damien Colletti
Video Madman Robert Noel Gifford

Lighting by Ted D'Ottario

Cinematography, Editing and Music by
Robert Noel Gifford

Shot on Location in
Long Island City, New York, USA

INT. BEDROOM

Camera comes into view with man kneeling down in front of the camera just staring into it with a dead and lifeless gaze. He continues to stare into the lens as the focus on the camera goes in and out of focus do to the poor lighting.

After a few minutes of his dead stare he reacts slowly to the ringing of a phone that only he can hear, because no ringing is picked up on the cameras mic. He slowing looks down and even more slowly picks up the receiver to an old phone.

> **MAN**
> (bringing the receiver to his ear)
> Hello?
> (he shows no reaction to the voice
> he only can hear on the other end
> of the phone)
> How many do I have to kill
> before you STOP! How many?
> (his voice angry)

As he listens he slowly raises his head and once again looks directly into the camera. His face void of any emotion.

> **MAN** (CONT'D)
> (in a dead tone of voice)
> Yes, yes I know it was my fault.
> (he lowers his gaze to the ground)
> I am so sorry. Yes yes yes I know
> it was my fault. Yes it should
> have been me who died.
> (his voice now broken and low)
> I will always love you, I always
> do what you ask. Yes yes I
> promise. I promise I will make
> this one suffer.

He slowly returns the receiver to the base of the old phone and slowly returns his dead gaze into the camera. After a few moments he slowly stands and walks directly toward the camera and shuts it

off.

EXT. NIGHTTIME, OUTSIDE

From the cameras POV a dark haired woman is walking and talking on a cell phone a distance away. She is unaware that she is being staked and video taped. The camera then begins to shake as it is being placed down on a tripod.

The man then enters the cameras view from the left side. He kneels and first looks at the woman who still is unaware of his presence and then into the cameras lens. Satisfied the camera is recording he slowly moves toward the woman who is still fully engaged in her conversation and unaware of the man's approach. Just as he goes to grab her from behind the camera goes off.

The camera is turned back on and the man's face comes into view from a downward looking up perspective. He is not looking at the camera but from side to side in a nerves manner checking to make sure no one has seen the attack. He then looks at the camera with cold dead eyes and turns the camera down to the knocked out body of the woman. She does not make any movement. The cameras picks up his heavy breathing. The camera goes off.

INT. INSIDE, BEDROOM - NIGHT

The camera turns on and begins its operations to find focus. When focus is obtained it is on the bed of the knocked out woman. Her hands are taped together and over her head. Her blouse is opened revealing her bra. The camera then moves and pans her body showing her feet have been taped together also. The focus then returns to her face. The cameras view then slowly backs away a few feet and the camera shakes as it is being placed on a tripod. Focus again goes back and forth until the focus is obtained in the poorly lite room. The man enters view from the left side and stops in front of the camera checking to make

sure it is recording. Satisfied everything is functioning correctly with the camera he moves toward the woman on the bed. He hovers over her without a sound. He then begins to gently shake her.

MAN
Wake up. It's time to wake up.

She begins to slowly come to and reacts in shock and horror to the man staring at her. She then comes to realize that her hands and feet are bound. Just as she is about to scream the man puts his hand over her mouth.

MAN (CONT'D)
(in a low voice)
I will say this once and one time only. Shut the fuck up. Do you understand

She continues to try to scream locked in the horror of her situation.

MAN (CONT'D)
(still in a low and empty tone)
I said shut the fuck up, but no you think your better then me and don't have to listen, right.

Her eyes are wide in terror, she tries to free herself. But he then climbs on top of her pinning her with the weight of his body and pulls a folding knife from his pocket with his free hand and shows it to her. She stops all attempts to scream and move.

MAN (CONT'D)
(smiling)
Good girl, such a good good little girl.

He slowly removes his hand from her mouth and opens the knife.

MAN (CONT'D)
I think you and me are beginning
to understand each other,
right?
 (smiling)

Breathing heavy in fear she shakes her head yes.

MAN (CONT'D)
Good, that's really really good.
Because I would hate to have to
cut you open before you knew.

Still breathing heavy she lays still as he climbs off her. He walks out of view and she follows him with her stare. He walks back into view and sits down next to her with the old phone and knife in his hands. He places the phone down on the bed next to her and then closes the knife and puts it back in his pocket.

WOMAN
 (breathing heavy and in a whisper)
Are you going to kill me?

MAN
 (looking at her confused)
What?

WOMAN
 (saying a little bit louder voice)
Are you going to kill me?

MAN
 (laughing)
Kill you? Kill you? Who the fuck
do you think you are asking me
anything.

WOMAN
 (in a scared voice)
Please I'll do anything, but
just don't hurt me.
Pleaseeeeeeeeeeeee

 MAN
 (getting angry)
 Anything, you bitch, I am a
 married man. I don't want you to
 do nothing. You understand me
 (getting up off the bed)
 Nothing, I want nothing from YOU!
 NOTHING.

He begins to pace coming in and out of view as
the camera's auto focus try's to keep pace. Then
without warning he stops dead in his tracks.
Everything is silent.

 MAN (CONT'D)
 That's her.
 (moving toward the phone)
 That's her calling.

No sound of ringing is picked up by the mic. He
is the only one who can hear the ringing.

 MAN (CONT'D)
 (looking at her in anger)
 You don't hear it do YOU!

She does not answer out of fear of what he might
do

 MAN (CONT'D)
 (walking over to her and going
 face to face)
 You don't hear the phone ringing
 do you!

She shakes her head no slowly. Her eyes wide in
terror as she is eye to eye with him.

 MAN (CONT'D)
 (breathing heavy in anger)
 They never hear it.
 (he backs away from her a few feet)
 None of them hear it. NONE!!!!!!!!

He begins to hit his head with his right fist.

 MAN (CONT'D)
 They never hear it. NEVER NEVER
 NEVER.
 (he stops hitting his head and
 looks at her)
 Not until I begin to cut them.
 Then they hear it. Then the all
 hear it.
 (smiling)
 Do I need to start cutting you so
 you hear it?

She instantly begins to shake her head no and
continues to shake her head.

 WOMAN
 I hear it, I hear it, I really do,
 I swear to God I hear it
 (her voice broken in terror)
 I swear to you I hear it. It's
 ringing and I can hear it.

He just looks at her in a dead gaze. He pulls out
the knife again and slowly opens it.

 MAN
 I know your lying to me. You
 think I'm stupid. That I would
 not know your lying.

Shaking her head no

 WOMAN
 I swear I really hear it. I do I
 swear to God I do.
 (lost in fear)

Staring at her a few moments he folds the knife
closed and puts it back in his pocket. The then
looks at the phone before walking over to it. But
he does not answer.

 MAN
 (in a low dead tone)
 She won't stop. She never stops.
 (his voice begins to change into a
 sad tone)
 She blames me.
 (he continues to hear the ringing
 that only he can hear)
 She never stops.
 NEVER..............

Looking at him she does not say a word.

 MAN (CONT'D)
 (still looking at the phone)
 She blames me for killing her. I
 told her it was not me, but the
 other one. The one who hides in
 the shadows, but she still blames
 me!!!!!
 (looking at her)
 Now she is with the other one
 and he tells her what to do.

She looks at him with wide eyes, but does not dare say a work that might anger him.

 MAN (CONT'D)
 He tells her it was my fault. But
 I only did what he told me to do
 (looking at her hoping she will
 understand)
 I only did what he said. He told me to
 cut her open.

She reacts to this with a gasp, but controls herself before she can scream. Her eyes still wide open in terror as she is locked in a gaze with him.

> **MAN** (CONT'D)
> He told me to cut the evil out of
> her. What could I do
> > (his voice pleading)
> I had to get the demons out of
> her. I had to cut and rip them
> out.
> > (his voice returning once again to
> > the anger tone)
> I ripped and cut until there was
> nothing left to cut. The demons
> got away. Now she wants me to
> find them and cut them out of
> anyone they hide in.

Looking at her with a wicked smile. He then gently starts to play with her hair.

> **MAN** (CONT'D)
> And I know that they are in you.
> She knows they are in you and
> wants me to rip them from you
> piece by piece.

She tries to scream but again he covers her mouth before she can do so. He raises his fist in the air to strike her and just as it lowers the camera shuts off.

INT. BATHROOM

The camera turns on and again tries to find it focus. The woman is chained to the shower railing and her mouth gagged. Her shirt is gone and she is in her bra. She is out cold from the punch. He comes into the cameras view holding the knife in his hand. He first looks at her and then into the camera again checking to make sure everything is working correctly with it. He then turns to the woman again and begins to point her in her arms

> **MAN**
> Wake up.
> > (pointing her in her arm)
> Wake up, time to wakey wakey

She slowly begins to come to

> **MAN** (CONT'D)
> (smiling)
> Good.................. such a good
> little things
> (he begins to play with her hair
> again)
> Come on you can do it

She comes to and is confused at this new nightmare unfolding before her.

> **MAN** (CONT'D)
> You awake now
> (still playing with her hair)
> She soon is aware of what is
> happening and begins to panic.

He grabs a fist full of her hair bring her face to his

> **MAN** (CONT'D)
> Enough
> (flashing the knife)
> Stop moving

Seeing the knife she stops fighting.

> **MAN** (CONT'D)
> Time to get those demons out of ya

He moves in front of her blocking most of her body from the camera. He then begins cutting into her stomach. She violent moves her head and tries to scream but her screams are muffled by the gag. The camera begins to search for focus again and the video becomes poor, but the mic still is picking up the cutting and the muffled screams of pain. When the camera's video improves his back is still to the camera blocking most of her and he is pulling the like a rope out of her her bloody intestine and most of her fight is now gone. She goes limp as he continues to pull out her bloody intestine.

Camera shuts off..........

INT. INSIDE, BEDROOM

The camera turns back on and finds in focus. He is staring into the lens with a dead stare. He is covered in blood. After a minute of so he gets up and walks out of frame. The camera then finds its focus on the phone on the bed. A door is heard off camera opening and then closing. The camera remains on the phone for a minute of so. Then the phone begins to ring breaking the silence.

-END-

8

BEER CELLAR

*"... you're just organs for sale,
nothing more than meat!"*
<div align="right">Mary</div>

Original Short Story:
Beer Cellar
(Synopsis only)

On the news channel a reporter is relaying the story of two sisters who have gone missing while hiking.

A man pours himself a drink, takes a sip and tops it up. His wife strokes his shoulder as she wanders passed him with her drink in hand and locks their front door.

Snuggling together on the couch, the couple stare blankly, the husband takes another sip of his drink and his eyes wander to the basement door.

In the basement, tied up, naked and trembling in fear are the two missing girls.

Mary turns to her husband Josh reassuring him that what they are doing is just and will aide in the greater good. Their devious plan of selling black market organs will pay off their huge debt. Josh is the weak link and has urges his wife cannot, or is reluctant to, satisfy. Whenever her back is turned, he sneaks to the basement and indulges in perverted graphic rape of the two girls, raising a hand to them to make them more compliant with his needs.

Mary is not easily fooled and is well aware of her husbands indiscretions and she in turn gets her kicks from seducing the mailman.
The couple continue to up the risk factor and the fear of getting caught by their spouse becomes more and more of a turn on.

Noting the times her husband indulges, Mary sets up a plan of action, she lures the mailman in to the dark basement and begins to have sex with him when Josh descends the stairs.

A fight breaks out and in the process the mailman must be silenced, Mary slices his throat spraying blood over everyone, the two sisters see this as an opportunity to escape and during a scuffle they lift

the keys from around Josh's neck. As one of the sisters sets herself free she draws attention to herself, Mary and Josh leap at them, knives lashing out. One sister is stabbed in the stomach the other fights off Josh, disarming him and using the knife to stab both Mary and Josh in their genitals, a slow death awaits them.

The dying sister with her last words tells the survivor, "Tell mum I love her" the surviving sister weeps over the body and then begins to climb the stairs, Mary, still alive lashes out slicing her Achilles tendon and as she falls to the floor, Josh pounds her head with a brick. They all die.

Behind the Cellar Door:
The Making of Beer Cellar

The positioning of films became more and more difficult and it wasn't until the assigning of directors that the order started to fall in to place. Beer Cellar was the last film to be assigned a director, I had approached four directors all of which said the film was beneath them which angered me, I then sent the script to two first time directors, both showed a great deal of interest but were nervous to take on such a responsibility. I did my best to boost their confidence but understood their reluctance. Both of those directors added to the screenplay and helped its development and all of a sudden I thought to myself, 'why can't Blaize direct this segment and lets make it the first segment of the anthology?' I opted to become assistant director and give Blaize as much help as she needed, but within an hour of shooting she was well suited to the role and needed very little guidance, she knew what she wanted out of the actors, who all gave impressive performances, they were even surprised to hear that Blaize had never directed before.

" I was nervous at first but thoroughly enjoyed it, Dave and the cast and crew were great and helped me feel at ease"

Blaize-Alix Szanto – Director

The story, being only a synopsis, was put through many drafts and received input from other writers before the final script was approved by Blaize. Early on it was added that the setting of this film was to be in a beer cellar rather than just in a residential basement, this meant finding a location wasn't going to be easy. Luckily a friend of mine was the landlady of a bar in south Wales and she gladly offered it to us, obviously filming would be restricted to the hours the bar was closed, so long nights were planned, this wasn't too bad, but the height of the cellar was a lot lower than I had hoped, so for Nathan and myself, both being six footers, it was not the most comfortable of locations. One element of the script progression that was approved, but later scraped, was the couple having a child, the character was removed due to not legally being able to gain a child actor available to shoot late hours.

The crew set out from Sussex and arrived at our hotel base camp for the two day shoot and filming began at 2am running through until 11 am for two consecutive nights. This did lead to all of us feeling very tired.

"It may have just been my tiredness and/or the booze, but I remember it being a really fun and fluid shoot although when trying to say my last lines at silly o'clock I was falling asleep and someone had to slap me HARD to wake me up!"

"The ceiling in the cellar was MEGA low and I had to manoeuvre in the most unusual positions...."

Nathan Head – 'Andy Deen'

Shooting in a Bar was an interesting experience and one I was particularly fond of as I also have a qualification in Parapsychology and the Bar has been known to have experienced some spooky goings on, sadly we were too busy with the film to have explored any spooky shenanigans although we did have to stop filming at one point due to the discovery of a drunken patron who had fallen asleep upstairs before the pub had closed. Comically he was nicknamed 'Ricketts' as when he is drunk, and he often was, he develops a certain way of walking.

Playing the young bar owners were Juliette and Nathan. I had seen their work before and had always wanted to work with them, I was so happy to have had them on this shoot and despite the long hours, everyone did a fantastic job and I am so honoured to have been part of it and even more happy that they enjoyed the experience too..

"In the acting realm you are often confronted with risks, Blaze of Gory fell into the risk category for me as I found myself driving for 7 hours to a place I didn't know, to work on a film with people I had never met - a horror movie in itself. As soon as I met the team I knew instantly it was a risk worth taking. So much fun, so much passion, hard work and very talented, admirable people. Unforgettable."

Juliette Strange – 'Emma Deen'

The roles of Kelly and Melanie took some time, I started looking for a pair of girls from eastern Europe as I felt the characters would be ideal as foreign students back packing on a gap year. We've all seen films where western youths go off to eastern countries and meet their demise but rarely the other way around. During the negotiations I was inundated with audition tapes and there were two UK based actresses that stood out above the rest. Their performance in this film is outstanding and I recall during one scene they had me tearing up as their delivery was so powerful.

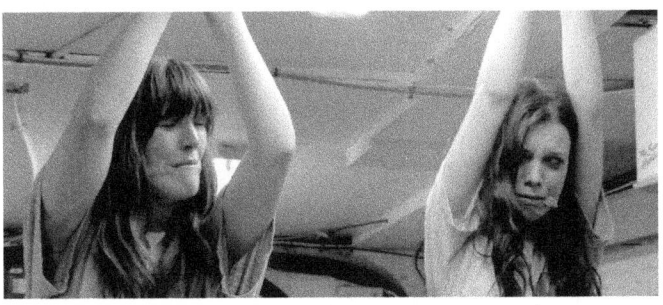

During the fundraising stage of this anthology, perks were offered to those who donated, as a result the names of Josh and Mary were changed to Andy and Emma Deen, also, all of the missing person posters were added to the film and show the faces of some of the donators.

Original Concept artwork

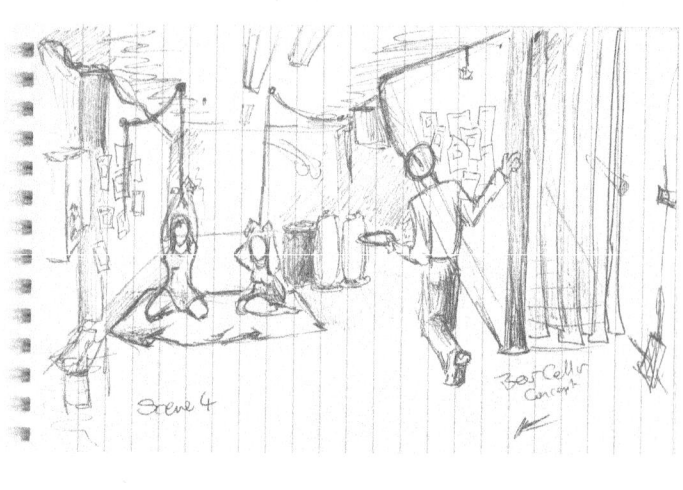

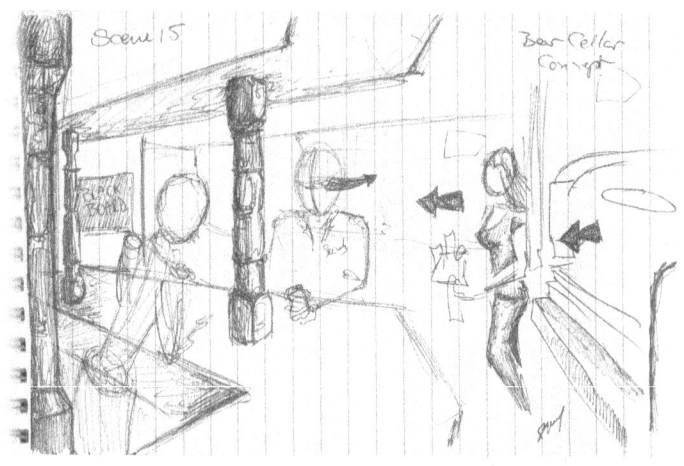

This film was now scheduled to be the first segment and so I felt the need to up the gore level so that we have a nasty film to kick off the anthology, speaking with Lucy the FX artist I drafted up a very basic check sheet for her to work from. Having done quite a few FX scenes I know, as does Lucy, how much preparation is needed and we were able to inform the director of how best to shoot the sequences as well as explain to the cast exactly how the scenes would play out.

As a last minute addition I spoke with Lucy and we were able to add a castration scene to the segment, it really allowed us to increase the gore and add to the overall anthology.

> *"My fondest, or should I say weirdest, memory is that I remember sitting in a pub in Wales in the middle of the night painting a penis"*

Lucy Claire Brennan – Make up

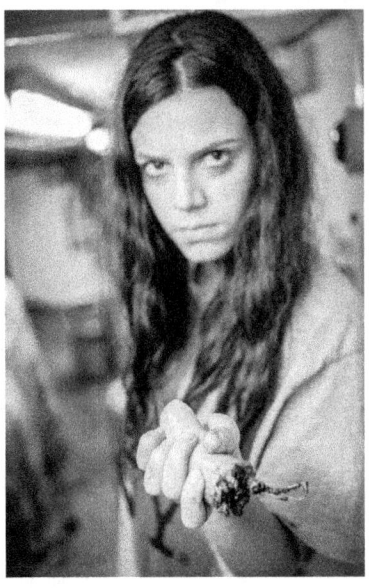

Beer Cellar FX List

These were my notes that I sent to Lucy the FX artist.

Who	What	Notes
EMMA Juliette Strange	Film Climax Stabbed in lower abdomen	**Gore** We need to go real nasty and stab her in the under-smile? Need to have a big splash of blood. This needs to look violent so how does stab happen in order to look nasty yet remain safe. **Hair and Make up** She has quite large hair, very curly, need to somehow tie it up but keep it sexy
ANDY Nathan Head	Throat slashed in one swift movement Last minute Addition. He is castrated	The Knife exits Mary and slices across his throat – shot from behind so lots of blood spray, show wound as he falls dead. He can be clean shaven no problems Fake appendage
KELLY Sabrina Dickens	Punched in the face on day one Kicked to death on day two	General tired make up, smeared eyeliner due to tears. Bruising to wrists and neck from restraints and aggressive man handling Kelly and Melanie are to be sisters, Sabrina is from Cardiff, Kate from Bristol but can do a welsh accent.
MELANIE Kate Davies	Stabbed, then repeatedly stabbed all over	Many stabs to stomach area, first stab will be heavily featured on camera and a crime of passion. The other stabs will be maniacal She will be wearing either a blue hospital gown or a tee shirt. the gown is a bit of a git with the blood as things tend to bead up so most likely a t shirt after she's been stabbed we need to reduce her colour considerably
SETH Craig P Cottingham	Head caved in by mag-light torch, numerous hits	Mary hits him in the head, he falls down then she pounds his head to mush. I will make a torch out of from foam for hitting actor, I also have a metal one if needed he needs to look a bit brutish, perhaps remnants of a black eye from a work related scuffle, maybe redden his knuckles too, giving him the bad boy look

This segment originally had a different opening scene incorporating cameos by the two owners of the pub in which we were filming.

Beer Cellar Original Opening Sequence	
EXT. PUB - FRIDAY - AFTER HOURS Several patrons leave the pub in various states of drunkenness. CUT TO: Inside the pub as SETH the stereotypical doorman is checking the toilets. DARREN staggers out of the gents as SETH holds open the door, **DARREN** Sorry boss. He leaves as Seth checks the empty gents. He moves to the ladies and knocks on the door, no answer so he pushes open the door. **SETH** Hello? Again no answer so he enters and checks the stalls, in the third stall is AMBER, she's is passed out drunk, Seth knocks on the stall door to get her attention, nothing. He taps her shoulder and she stirs, she pulls up her pants and tries to stand, he helps her, Amber struggles to walk and leans in to him.	**AMBER** You are so hot, take me home. **SETH** Come on luv, I'll call you a cab. **AMBER** What's the matter, are you queer or something? Don't you wanna fuck me? **SETH** Come on, you have to leave now. Amber lifts her shirt exposing her breasts to him (not the camera), he shows no interest, his eyes roll. **AMBER** Fucking poof! She lowers her shirt and staggers out. CUT TO: **EXT. PUB** As Amber leaves she finds Darren and the two start to make out.

It was felt that this scene was a little unnecessary and did not add anything to the story and was therefore dropped.

Beer Cellar
Shooting Script

Directed by Blaize-Alix Szanto
Additional material Directed by Lord Zion
Screenplay by David V G Davies
Additional writing by Jason Jay White and Duff Eynon

Emma Deen	Juliette Strange
Andy Deen	Nathan Head
Seth	Craig P Cottingham
Kelly	Sabrina Dickens
Melanie	Kate Marie
News Anchor	Duff Eynon
Bar Patrons	Craig Matthews
	Marc Sinclair
	Gary Stratmann
	Linda Stratmann
	Blaize-Alix Szanto

Missing People
Harry Williams, Verity Crush, John Shelton
Lee O'Neill, Duff Eynon,
Olga Maya Matkovska, Lindi Peri,
Penny Judd, Kierron Holliet, Andy Morton,
Andrew Nelson, Charles J Chan

First AD / Camera	David V G Davies
DOP	David V G Davies
	Craig Matthews
Lighting / Still / Sound Recordist	Craig Matthews

Make up	Lucy Claire Brennan
Prosthetics	David V G Davies
Composer	Benjamin Symons
Editor	David V G Davies
V FX Compositor	David V G Davies

'Sex Song'
Written by Michael Trapp
Performed by CrimsonFaced
From the CD - Captain Freak
Bliss This Music
www.miketrapp.com

'Sublime'
Written by Michael Trapp
Performed by CrimsonFaced
From the CD - Lunatic Binge
Bliss This Music
www.miketrapp.com

Thanks to
Emma and Andy Deen
Jason Jay White and Duff Eynon
Jake Fitzjerald
Sian Smith and Mark Snowcroft

Shot on Location in
Pontyclun, Wales, UK

INT. PUB

Seth locks the doors and looks over to ANDY (clean shaven with his shirt sleeves rolled up)and EMMA slightly younger than ANDY, wearing a skirt and a black shirt with 3/4 length sleeves and an apron).

 SETH
 All done.

 ANDY
You staying for one tonight man?

 SETH
 (exchanging a very quick nervous
 glance with EMMA)
Yeah cheers dude. Just for a
quick one though yeah?

ANDY turns his back on them and makes a Jack Daniels and Red bull with one ice cube. He also makes a Pernod and blackcurrant for EMMA. SETH stands next to EMMA and runs his hand down her side and around to her bottom but moves his hand away as ANDY turns to them and pours himself a pint of cider.

The Television set shows a news report about missing teens.

 NEWSCASTER
 ...an update on the local missing
 Lannister Sisters today as it is
 believed that the girls may have
 traveled as far as Dover looking
 to cross in to France...

ANDY and EMMA notice the screen and quickly grab the remote and SETH goes to say something.

 SETH
 Bloody teenagers. They go bogging
 off around the world with no
 knowledge of the country it's no
 wonder they go missing.

EMMA and ANDY exchange looks (discretely)

 ANDY
 (nervously)
 They'll turn up. Probably on a
 bender in Paris, they'll be back
 in a month looking for mummy and
 daddy to give them more money.

 SETH
 Yeah man, probably right. Any
 way, I better go.

He finishes his drink and gets up EMMA also gets
up and walks with him to the door, where she
unlocks it and as SETH leaves he turns to her.

 SETH
 So come on then, when are you
 gonna leave him? You can't keep
 me dangling any longer. It's
 doing my fucking head in.

 EMMA
 It's not that easy. We're still
 tied up in this place, but we've
 got a few things in the works
 that should speed up the
 payments and then we can pay off
 the debt. cant we just keep it
 like this, casual?

SETH, leans in to kiss her, but she looks back
inside the pub and then shakes her head at him
and closes the door.
EMMA locks the door as ANDY places the three
glasses on the side and he moves to the stairs.
EMMA joins him on the stairs.

He checks the lock on the basement door and then follows her up the stairs. Shot from the bottom of the stairs keeping the basement hatch in frame.

INT. BEDROOM - SATURDAY - EARLY HOURS

ANDY wakes and looks over at EMMA who is asleep. Her hand is on his shoulder but he shrugs away and a frown appears on her face, he pulls back the covers, exits the bed and sneaks out of the room.

INT. PUB - STAIRCASE

ANDY, in only his shorts, tiptoes down the stairs, looking back up the stairs; making sure he hasn't woken EMMA from her sleep. He gets to the bottom of the staircase and from his neck he takes a key on a chain. Using it, he opens the basement door, again checking up the stairs in order not to wake EMMA.

INT. BASEMENT

ANDY descends in to the basement area. He stops at a large dustbin, next to which is a collection of bowls. He picks one up and opens the dustbin, inside which is a strange food.

He shovels a load in to the bowl and continues in to the dark basement.
He pauses and looks down out of camera shot.

ANDY
Hey there, have you been good...
I bet you have, look I brought
you some supper.

He bends down and instead of a dog there are two tied up ladies, it is the Lannister Sisters from the earlier news report. MELANIE(24) She is wearing a dirty t-shirt, which is obviously a mans as it is far too big for her. She is gagged

and her makeup has run, but her eyes are wide in fear at his presence her arms are tied above her head by a chain. Behind her there are posters of missing people, including one of her and her sister. Next to her is KELLY (20) she is dressed and restrained in the same way, but she is more slumped down.

ANDY
According to the news you made it to Dover! now the heats off we can move you away from here, tomorrow I'll call the boss and arrange it.

ANDY reaches out and pulls down KELLY's gag, pushing the bowl in to her face so she can't scream but only eat the contents, he replaces her gag then moves to MELANIE. Tilting the bowl so she gets most of the food, a piece of food drops out and lands on her chest. he pulls the bowl away and replaces her gag.

ANDY
(his hand wiping away the spilled food)
It'll be a shame to see YOU go,
(his attention shifts to Kelly)
Both of you.

His attention returns to MELANIE He looks at her in great detail and runs his hand over her body while his other hand slips in to his own shorts. He grabs at her shirt scrunching it up exposing her bare midriff, he drops out of frame to his knees. close in on her face as we only imagine what it is he is doing.

CUT TO:

INT. BEDROOM

EMMA wakes and looks to see her husband, but he is not there. She gets up, throwing the sheets to one side in one swift movement.

CUT BACK TO:

INT. BASEMENT

MELANIE POV

 ANDY
 (wiping his mouth)
 That was fucking fantastic. I bet
 you fucking loved it!

He then looks over to the right and the camera cuts to show what he sees. KELLY who is also tied up and gagged and looking at him in fear, perhaps crying. ANDY points his finger at KELLY.

 ANDY
 I'll see YOU tomorrow.

Close up of ANDY on the steps. His hand moves up to the light switch and he presses it.

CUT TO:

Show the captives as the lights go out, a small glimmer of light on their eyes. MELANIE is holding back the tears but KELLY is crying.

 MELANIE
 (muffled by gag)
 Be strong, we WILL get out of
 here, trust me. I'll make him
 pay, I promise.

INT. PUB - TOP OF STAIRS

EMMA exits the room but notices that ANDY is sitting on the top step. EMMA goes to put her hand on his shoulder but hesitates.

 EMMA
 Are you ok?

ANDY places his hand on hers.

 EMMA
I know we have been drifting
apart but I'm hoping we can sort
it all out, as soon as we sell
these two off we're almost done
on the debt, maybe 4 more and we
can just up and leave, make a
fresh start,
 (he turns to her)
what cha say? we CAN get through
this yeah.

EMMA sits down next to him and touches his knee, he looks at it and up at her, camera pulls back down steps.

EXT. PUB

Establishing shot of the location which now seems more sinister than the earlier one.

 PASSAGE OF TIME:

EXT. BEER GARDEN - 1030AM

ANDY moves some chairs and places beer mats and ashtrays out in the beer garden.

INT. PUB KITCHEN

EMMA watches through the window, then looks down in to the sink where there is a knife. She grabs it and exits frame.

INT. BASEMENT

The light sparks on The 2 victims all tied up, try to shield their eyes from the light. EMMA descends the steps. She is very determined and furious. She stands in front of them.

 EMMA
 Right!
 (pause)
 which of you was it?

She points the knife at each of them in turn,

 EMMA
 Was it you, you little cunt? I
 know he was in here. Don't play
 fucking stupid with me you whore!

The knife right up close to KELLY's face, almost pierces the flesh.

 EMMA
 He doesn't love you, he loves ME,
 he's ALWAYS LOVED ME and he
 ALWAYS WILL,
 (she turns away from them all)
 You mean nothing to him, he
 doesn't care about you. I DON'T
 care about you, you're all
 worthless and ugly, you're just
 organs for sale, nothing more
 than meat!
 (she turns back to them)
 You,

 EMMA (cont)
 (she puts the knife on MELANIE's
 cheek.)
 You are really ugly, you cunt!
 MELANIE
 (muffled by gag)
 Bitch!

EMMA pushes her back to the wall pulling the chain to its at full extension, she runs the knife over MELANIE's throat.

 EMMA
 (Whispering)
 He'll never love you,

EMMA turns her back on her, MELANIE takes a chance and taking the slack of the chain she tries to wrap it around EMMA's neck, EMMA is shocked but she managed to get her hand up to her neck, she turns to face MELANIE, the chain still around her neck, she thrusts the knife in to her stomach making her loosen the chain and slump to the wall.

 EMMA
 you fucking CUNT!

She pulls at MELANIE's gag.
 MELANIE
 (choking on blood)
 He was down here, not just once
 either, he fucked me good and
 hard and loved every minute,
 said he was sick of your dried up
 cunt, he wanted to taste a real
 woman.

EMMA in a fit of rage goes bat shit crazy with the knife ripping at her clothes and repeatedly stabbing her.

 EMMA
 Ugly, ugly, UGLY WHORE!

KELLY is up on her knees and her muffled screams go unnoticed by MELANIE and EMMA. EMMA stops stabbing, MELANIE slumps down to the floor exhausted and in serious pain, she will bleed out in very little time. EMMA then punches KELLY in the face.

INT. PUB BACK ROOMS

ANDY enters placing the unneeded ashtrays on the side,

 ANDY
 Ems?

Looking for EMMA he sees that the basement door is open, he moves up to it quickly EMMA exits the basement just in time

EMMA
Hey baby

Going to hug her he steps back, realizing she has splatters of blood all over her.

ANDY
What have you done? Don't tell me you've fucking been down there. You never go down there. Why the hell...

EMMA
(cutting him off)
Shut the FUCK up. I know what you've been doing down there. Well, not any longer. GAME OVER! Don't ever take me for a fool.

She locks the door and goes up stairs, stopping half way and turning to him.

EMMA (cont)
It's 11, open the fucking doors.

CROSSFADE:

INT. PUB

ANDY leans on the bar, one hand on his head the other tapping the basement key on the bar. He glances over to it but into frame of focus as so close) steps EMMA. She has now changed and is no longer covered in blood.

A lasting glare between them is silenced by a PATRON entering the building.

Close up of a beer being poured.

CROSS FADE:

INT. BASEMENT

MELANIE is still alive but is badly wounded, she is slumped on the ground, she cannot pull herself into a comfortable position. Slow pan to KELLY. She is crying with little sound. She looks over at her sister, the anger grows.

> **KELLY**
> Its gonna be ok, we are gonna get out of here right?
>
> **MELANIE**
> (gasping)
> It's no use, I'm not gonna make it, tell mum, I'm sorry.

Kelly begins to cry, she tries to manoeuvre her legs to get closer to her sister, but she slips on the blood.

INT. PUB

The pub is now filled with people. ANDY is chatting in the background to a customer and serving them a drink. EMMA is cleaning a table when SETH enters the pub. He is early for his shift on the door. EMMA watches him as he enters and he looks at her as he heads straight to the bar.

> **ANDY**
> Sure, how was the gym?
>
> **SETH**
> Good cheers, really good

EMMA passes him and he watches her go.
She stands by the stairs and beckons him over.

 SETH
 erm, Any chance I can use your
 shower? It was err busy at the
 gym and I don't wanna be stinking
 before I even start working.

 ANDY
 Sure, no worries. You know where
 it is.

SETH picks up his bag and heads to the stairs to
where EMMA is standing.
The two meet at the stairs and she grabs him by
the hand and pulls him in to the basement.

INT. BASEMENT

The lights are off and EMMA is all over SETH. He
drops his bag as he tries to kiss her, she turns
her head and looks directly at the girls, MELANIE
is now unconscious. He is still kissing her neck
and unaware of the captives, as she continues to
look at them, She then pushes him back slightly,
turns around and lifts her skirt she continues
to watch the captives during this entire act. As
they have sex his attention is distracted by a
noise.

He stops his actions and squints his eyes to see
what it is that he's heard. he grabs his torch
and looks Show the captives in very low lighting
as the realization of what happens down here
dawns upon him.

 SETH
 What the fuck?

He completely stops what it is that he is doing
and after a pause, turns to EMMA.

 SETH
 What the hell is going on down
 here?...

SMASH, she grabs his torch and hits him in the head with it, he collapses to the ground.

EMMA
SHIT!! Fucking bastard. I was almost there.

She repeatedly hits him over the head with the torch until his head is mush and he has stopped twitching.

She then walks over to KELLY who had been making noise.

EMMA
You Fucking CUNT, look what you made me do, all I wanted is a moment of love and you FUCKING RUINED IT!

With the torch raised high she readies to brings it down heavy but is stopped just as ANDY enters the room. He turns on the light and then closes the door behind him.

ANDY
What the fuck are you doing? Are you insane?

EMMA
Fuck you! You were the one who caused all this, coming down here every night to fuck away the hours with these cunts!

MELANIE slumped in the corner very pale ties to pick up the knife but she has no energy and takes her last breath KELLY cries louder from behind her gag. her eyes notice the knife.

 EMMA
 (to ANDY)
 I loved you, but you were too
 busy thinking with your dick.
 That is NOT why we've been doing
 this. Do you understand?

 ANDY
 So how the fuck are we gonna make
 money now? Look at her and
 (he almost trips on SETH)
 FUCK man Shit what happened to
 him!
 Je-sus Christ!

Insert flash edits of the dead MELANIE and SETH.

 EMMA
 We still have her!
 ANDY
 But they're expecting four
 kidneys! Now unless you know
 something strange about her
 sodding genetics then we are two
 short right?

 ANDY (cont)
 (he steps forward)
 And how the Fuck are we gonna
 explain this?
 (to himself)
 Fuck sake. stupid fucking bitch!

 EMMA
 He's a fucking doorman, he's
 bound to have enemies, we say he
 never showed up for work and no
 ones the wiser, now wheres that
 knife,
 (to ANDY)
 go get me an ice box,
 (to herself)
 I'll give em six!

EMMA turns her back on KELLY to move towards MELANIE.

EMMA
Wheres the FUCKING Kni...

EMMA is cut off by the knife being thrust into her lower abdomen.

KELLY
Fuck this you crazy bitch!

Before ANDY can say anything he slips on SETH's brains and lands by KELLY's knees. KELLY pulls the knife from EMMA's body and in one motion slices ANDY's throat, spraying herself with his blood.

KELLY
FUCK YOU!

She grabs the keys from his neck and makes to leave the cellar.

-END-

Original Ending

This scene was cut on the day of filming as Blaize felt the film would be stronger if we allowed Kelly to live, it would give the audience at least one happy ending.

INT. PUB

Pan the pub as the patrons enjoy their drinks. A CUSTOMER is waiting at the bar looking to be served. Continue the pan as the door to the basement swings open and out staggers KELLY, bloodied knife in one hand and a brain soaked torch in the other. she swings for one of the PATRON's with the knife but misses as she is hysterical.

EMMA falls out clutching her wound and falls to the ground.

> **BAR PATRON'S**
> (hysterically)
> What the fuck, she stabbed EMMA, get her.
> (add screams etc)

People grab at KELLY as she lashes out. Struggling to get free, the camera tracks back as several of the patrons are both restraining her and beating her to death

DISSOLVE:

EXT. PUB

Track back

The sound of sirens can be heard.

During the killing of Seth, I left the script pages a little too close to the action.

She repeatedly hits him over the head with the torch until his
head is mush and he has stopped twitching.

She then walks over to KELLY who had been making noise

 MARY
 You Fucking CUNT, look what you made me
 do, all i wanted is a moment of love and
 you FUCKING RUINED IT!

With the torch raised high she readies to brings it down heavy but
is stopped just as JOSH enters the room. He turns on the light and
then closes the door behind him

 JOSH
111 What the fuck are you doing? Are you
 insane?

 MARY
112 Fuck you! You were the one who caused all
 this, coming down here every night to
 fuck away the hours with these cunts!!!!

113 MELANIE slumped in the corner very pale tips to pick up the knife
but she has no energy and takes her last breath

KELLY cries louder from behind her gag. her eyes notice the knife

 MARY
 (to JOSH)
114 I loved you, but you were too busy
 thinking with your dick. That is NOT why
 we've been doing this. Do you understand?

 JOSH
115 So how the fuck are we gonna make money
 now? Look at her and
 (he almost trips on SETH)
 FUCK man Shit what happened to him!
 Je-sus Christ!

(F) Insert flash edits of the dead MELANIE and SETH

 MARY
116 we still have her

 JOSH
117 but they're expecting 4 kidneys! Now
 unless you know something strange about
 her sodding genetics then we are 2 short
 right
 (he steps forward)
 And how the Fuck are we gonna explain
 this?
 (to himself)
 Fuck sake. stupid fucking bitch

 MARY

9

PRECIOUS

"Please help my baby girl"

 Mum

As a child born in the late seventies I was at an age to appreciate the boom of the video rental shop. I was an impressionable child and took particular notice of the fantastic covers of the horror selection that my local store had on offer for only fifty pence a night. My mum wouldn't allow me to watch such movies but my grandfather was more open to my understanding of what film was, as a child I remember his vast collection of betamax tapes. When I was approaching ten we had a new enterprise in town in the form of a mobile VHS rental wagon, at the beginning of the month we had a list given to us and we would tick off films we wanted to see, then every Friday the van would deliver a film and pick it up on the Monday. Luckily my father and I were film fans and he would allow me to pick the occasional title. By cutting out my mother from overseeing what we were watching we were able to see some brilliant movies, sadly some of which have never made it to DVD. Some of the films I remember most from this time were the horrors and in particular, anthologies such as Creepshow.

Working on an Anthology project was such a huge undertaking, especially keeping track of so many schedules. It wasn't until we were half way through preproduction that I sat down with Blaize and suggested the need for a wraparound story that linked all the films together. It would give the film an overall central point and base it all in a recognisable situation rather than just a collection of films.

With no immediate idea of a setting for the wraparound idea, Blaize worked on a first draft that was a list of different kill scenes and we planned to use them to link each story. Locations for our wraparound started with horror cliches that would relate to the films, for example a haunted house setting would link to the story If You Were Here. Believing this to be a stretch and that most of the stories didn't cover all the horror cliches such as monsters or slashers, we opted for the choice to set the wraparound in a therapists office and different clients telling stories. This developed a little more and made it in to an early draft.

Wraparound First Draft.

Ways to die:

Therapist → Pen/pencil to the eyes and then stabbing in the stomach.
As they are on the floor, the person that stabbed the therapist runs and stamps on the therapists head.

1 - Runs down corridors with bright white walls and has flashbacks (young and naive) and stops dead in the middle of the corridor. Takes a razor out of pocket and starts slicing at arm. Then drops razor to the floor — blood dripping, and then slams head against the wall so hard that it begins to crack the skull and they die.

2 - Boy (man) is playing with toy plane whilst talking to the therapist and then the therapist mentions his brother breaking plane and he goes ballistic and starts breaking the plane up and eating the parts — he chokes and dies.

3 - Girl (snow white) is laying asleep on the sofa with therapist talking. She has a nightmare about what happened and begins pulling her hair out. The therapist tries to stop her but gets too violent and ends up choking her to death. (hands round neck so tight she can't move - turns out it isn't a therapist it is one of her personalities).

4 – Sitting talking to therapist, and then then TV in the corner turns on with the movie from the story (fetus come alive) starts playing and she screams and runs into the corner something (one of the things (dad) from the story) comes out of the TV and runs to her, reenacting part of the end scene – but he isn't really there – it is her imagination and she kills herself – stabs herself in the heart.

5 – Girl is talking to the therapist with a vacant look in her eyes and not really concentrating. She is staring at a picture (punching) of the woods on the wall and she starts having a panic attack. She begins hyperventilating and she clenches her stomach so hard her fingers go into it. A weird zombie foetus thing crawls out and wraps the umbilical chord around her neck – killing her (spawn of the devil).

During the collaborated writing of the wraparound, we felt having a death before each film might be too much and appear to be a rushed element, especially with each part of the wraparound being approximately 2 minutes in duration, The death scenes were moved and it was developed that the story would become a continuing story that would set up each segment as well as tell its own story.

The basis of the wraparound began to take shape and it grew in to a story that would revolve around Blaize and her Mother in a fictional scenario with Blaize being possessed by the Devil leading to her having hallucinations. It was at this point that we finally chose an order for the films, this was in itself a difficult task as we wanted there to be a natural flow to the films.

In the wraparound, the camera would focus on several items, the order of these items was decided upon aesthetically and thusly the order of films was decided.

Designated Film Order

Beer Cellar
If You Were Here
Sick Little Boy
Young and Naive
Abort
Snow
Masque of the Red Rape
Monster

Casting of our wraparound was an important task as these would be the first cast members introduced to the full anthology. An audience would need to connect with these characters and want to follow their progress. I've known Emily Booth for a few years now and had the pleasure of working with her on several projects, I was delighted when she expressed interest in portraying the role of the mother and liked the script. This would be Emily's first role as a mother and not as a victim. Having her on board was a pleasure and also added a well known mainstream British horror star to our assemble cast. A good friend of mine has often expressed his liking of Emily and as a favour to him a role was added and a scene for him and Emily was developed. To this day he hates his performance, he said he was so in awe he could hardly talk.

> *"It was amazing to be offered the chance to work opposite Emily, I've had a crush on her for years! Definitely one ticked off my bucket list, shame I look and sound like a proper Bristolian twat farmer"*
>
> Antony Hughes

Charlotte Snowball was cast in the lead role, she is sweet and innocent looking which was perfect to carry off the role. Charlotte was scared when she saw herself in a reflection while in the possessed makeup and almost brought to tears so we didn't show her too much of the footage, make up artist Justin did an amazing job of possessing this sweet girl.

Filming took place over two days in Surrey with Jason Wright at the helm. At the last minute Jason's planned camera operator dropped out due to complications and I stepped into the role, I never think of myself as a DOP but I must admit, this Blaze Project has definitely thrown me in at the deep end and I feel a sense of accomplishment that I have had the opportunity to work on so many films in such a short period of time and alongside so many talented people, not only that but I have had a complete blast doing it.

The wraparound script was tight with little room for elaboration which at the time was great, however when all the segments were completed and the wraparound was being implemented a problem arose. With each films runtime varying between 7 and 16 minutes, it meant that cutting to a 1-2 minute wraparound sequence didn't seem to work as we had intended. In hindsight a wraparound would have worked had there been only 3 or 4 films but with 9, it spread the wraparound too thinly. It took a while of throwing ideas around and Blaize, Jason and I decided that with a slight tweak, the wraparound could become a self contained segment, in the end only one scene was cut. Now titled Precious, the wraparound was re cut and signalled the final stages of the anthology.

"It was great to be part of this anthology and to work with like minded people all on the same page."
Jason Wright - Director

"I was well happy with the freedom I had with creating the look of the girl in this film and more happy that the producers loved it"
Justin Becker - Prosthetics

"Once again, when I agree to do a film with David, I end up washing blood out of every crevice"
Emily Booth

"I love working with Emily, she always brings that high level of professionalism and allows me to push limits. I wanted her in this film from the start and glad she enjoyed the role"
David V G Davies

Precious
Shooting script

Directed by Jason Wright
Additional Material Directed by Lord Zion
Screenplay by David V G Davies

Lea-Anne	Emily Booth	First AD	Kirsty Richardson
Blaize	Charlotte Snowball	Second AD	Sonia Mason
Exorcist	Rudy Barrow	Cinematography	Jason Wright
Team Impact	Antony Hughes	Camera / DOP	David V G Davies
	Chris Howley	B Camera	Lauri Saska
TV Voice	Duff Eynon	Sound Recordist	Laura Hayden
Satan	Marc Sinclair	Lighting/gaffer	Alice Connolly
		lighting assistants	Bethany Horrell
			Lauri Saska
Concerned	Lucy Claire Brennan	Make up & Prosthetics	Justin Becker
Neighbours	David V G Davies		'Nightmares SFX'
		Make up	Nicola Richardson
		Composer	Ken Hampton
		Editor/VFX Compositor	David V G Davies
		Runners	Bethany Horrell
			Tim Rantle
		Set Decorators	Laura Hayden
			Bethany Horrell
		Spit Catcher	Tim Rantle

Thanks to
Lucy Claire Brennan and Paul Hobday

Shot on Location in
W.Sussex

EXT. AVERAGE HOUSE. DUSK

Establishing shot of a normal looking residence, perhaps a couple of kids run past the driveway.

CROSS FADE:

INT. AVERAGE HOUSE

Creepy tracking shots, revealing a staircase, at the top of which we see a girls feet move from one room to another. More creepy tracking

INT. KITCHEN

MUM is downstairs cleaning in the kitchen, on the kitchen sideboard is a small 7inch monitor, on it is a documentary on paranormal activity
insert close up of feet upstairs enter a room and the door slam.
MUM hears the slam and puts down the item she is cleaning from the top of the stairs Mum enters frame and looks up towards camera

INT. ROOM

The girls feet pass the camera knocking a bag over, its contents spill out, one item is a brochure on back packing in Wales without seeing her face she jumps on to bed and cracks open a can and flicks on the tv.

Images of nightmarish material including images of The Devil

INT. BEDROOM

Low angle to see the the edge of the bed, the girls hand drops into frame dropping the remote control

INT. HOUSE

From top of the stairs MUM looking up
No answer

 MUM
 Are you ok love?
 (pause)
 Turn the tele off and come get some tea

INT. BEDROOM

From the point of view of the girl at the TV static, her foot in the frame twitches as the static on the tv darkens as does the whole room.

INT. HOUSE

From the top of the stairs looking down the MUM looking up steps forward and looks annoyed at being ignored.

INT. BEDROOM

The bed thumps its legs on the floor

INT. HOUSE - STAIRCASE

MUM looks anxious another thump and she fastens her speed top of stairs.

INT. BEDROOM

MUM opens the door high contrast flashy lights as MUMs face is one of shock. crash zoom intercut with face of SATAN

INT. HOUSE — UPSTAIRS

outside girls room MUM shuts the door she looks terrified as from within we hear screams and slams, she runs downstairs holding back from being sick.

INT. HOUSE KITCHEN

She reaches the kitchen sink and then vomits into it, next to the sink is the monitor still showing footage of the paranormal investigation documentary. Close in on the monitor screen (* this time its a series of stills with a voice over) there is a number on the bottom of the screen.

> **TV VOICE OVER**
> Do you believe in UFOs, astral projections, mental telepathy, ESP, clairvoyance, spirit possessions, telekinetic movement, full trance mediums...

Fades out as as heavy thumps from upstairs drown out the sound of MUM vomiting.

INT. BEDROOM

The girl is blatantly possessed we see her point of view as the DEVIL rapes her, she claws at her belly attempting to rip open her own stomach so hard her nails cause deep scratches.

INT. HOUSE STAIRCASE

MUM sitting on the stairs crying mirrored by

INT BEDROOM

Screaming face of the girl in a mirror then the mirror is shattered as the girl throws something at it.
The Devil performs a crude delivery of a deformed baby.

EXT. HOUSE

Establish the team of three , two of them have head mounted GoPro's which we then cut between. Pi team cam front door opens to show the mum in this scene include concerned neighbours.

 CUT TO:

EXT. STREET

Two shadowy figures stand watching, they keep their gaze fixed then the younger man speaks.

> **SATAN'S BUTTBOY**
> It is coming soon Father

INT. HOUSE

Cinematic reverse angle as over the shoulder of the mum as she looks at the paranormal team, the main exorcist and the two camera guys (Chris and Tony) Mum tries to say something, but the exorcist raised his finger stopping her, he looks around then closes his eyes and tilts his head.

> **EXORCIST**
> I believe we should begin

From up stairs thuds can be heard

 inter cut:

The girl cowering in the corner of the room she is dirty, cuts on her face, the room is trashed. heavy possessed makeup.

> **MUM**
> (crying)
> Please help my baby girl

INT. ROOM

Combination of cinematic and GoPro, The paranormal investigation team enter the room narrowly being missed by a projectile being thrown by the girl. She is sitting on the bed and is pulling her hair out, she leaps at her mum and tries to choke her but the team pull her off and pin her to the bed MUM is taken out to the landing by TONY.

 MUM
It's like she hates me

Screams coming from the other room

INT. ROOM

The paranormal investigation team are tying holding her down on the bed trying to stop her from lashing out hurting them and herself.

INT. LANDING

Mum and Tony are chatting, we are mid conversation

 TONY
It's ok, we are gonna do everything we can,

 MUM
I feel so helpless, how did this all happen

 TONY
Its best you wait downstairs, with your boys or is there a neighbour

INT. ROOM

Tony re enters and places his metallic flight case on the side, from out of it he pulls an

interesting looking instrument and begins doing some readings

EXORCIST

> I'm calling out to the spirits in this room, can you tell us your name?
> (pause)
> can you tell us why you are here?

Include close up of the girls possessed face during all this as she seems to respond to the questions with her eyes, NOT by talking.
(perhaps throw in some demonic language)
Add footage of the Devil

EXT. HOUSE NEXT DOOR

MUM is shaking being comforted by next doors mum and daughter.

INT. ROOM

CHRIS
(whispering)
Does she feel cold to you?

Before Tony can answer, the girls eyes shift she is cut off by a loud bang.

INT HOUSE

The mum sneaks back in

INT. ROOM

The girl breaks free of her restraints and attacks TONY and CHRIS then spits on the exorcist who slaps her around the face. TONY and PAUL pin her down not looking in her face as the exorcist hold her head and reads from a book.

> **EXORCIST**
> Our father who art in heaven
> Hallowed be thy name. Thy kingdom
> come, thy will be done, on earth
> as it is in heaven. Give us this
> day, our daily bread, and forgive
> us our trespasses, as we forgive
> those who trespass against us.
> And lead us not into temptation.

Plenty of struggle from the girl and swearing. the mums head peers in the room as the girl is pinned down.

> **GIRL/DEMON**
> (in Bosnian)
> Silovati (rape)

INT. ROOM

Everyone looks dead, blood everywhere, guts spilled out of some people, an eye missing from another. One person has pencils shoved in their eyes. Pan the room, Satan's Buttboy, is cutting open the girls stomach and pulls out a sack, in which is a demonic baby which he hands to his master.

> **SATAN**
> Cute

> **SATAN'S BUTTBOY**
> Too bad it can't stick around.

> **SATAN**
> It is needed elsewhere

A sink hole appears with flames emerging from it Satan THROWS the INFANT into the FIRE

More panning the room ending on the girls eyes, suddenly their eyes open and they are black

-END-

10

THE END IS NIGH

"You'll be very happy here"
 Estate Agent

The Beginning and the End:
The Making of the Titles and Credits

I have been a fan of opening credit sequences after I discovered the work of Kyle Cooper, a graphic artist who, along with Imaginary Forces, is responsible for some of modern cinemas most iconic opening sequences. Looking back at the majority of my favourite films, their titles have also been very impressive and being that the opening sequence has to grasp the audience and show, from the start, what to expect, I knew that this was going to be a very important task. The nature of this anthology by its title alone suggests it will be a nasty, gore filled ride, so I wanted to have a grisly death straight away.

Blaize and I worked on an idea that we felt would work well, it would incorporate a skinned body, an element that was dropped from one of her previous stories during the script writing process, so it was nice to have it back.

The basic outline of the opening titles takes place in a dungeon where Blaize has killed and skinned a girl. She uses the skin to make a book, that book becoming the Blaze of Gory stories. This simple yet effective plot enabled us to pay homage to some of Blaize and my favourite films, in particular, David Fincher's Seven (1995), Wes Craven's A Nightmare on Elm Street (1984) and Sam Raimi's The Evil Dead (1981). The idea also allowed for Blaize to make a cameo as herself which I felt was very fitting.

With a limited cast and crew we managed to film the sequence in our make up artists garage in a single afternoon. Michelle, who played our skinless victim took great pleasure in freaking me out while dressed in a Morphsuit™.

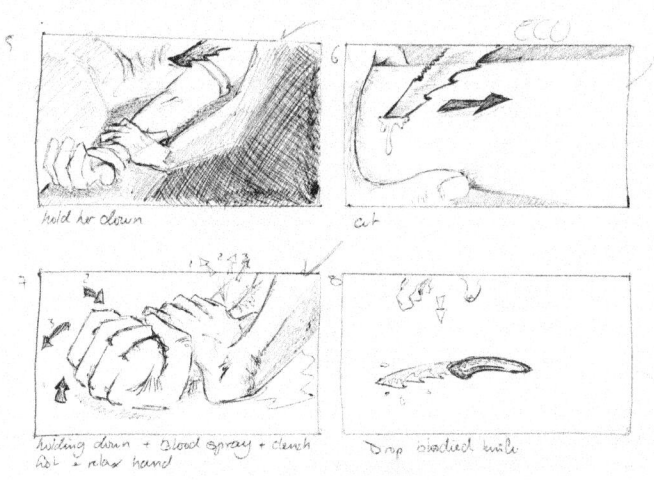

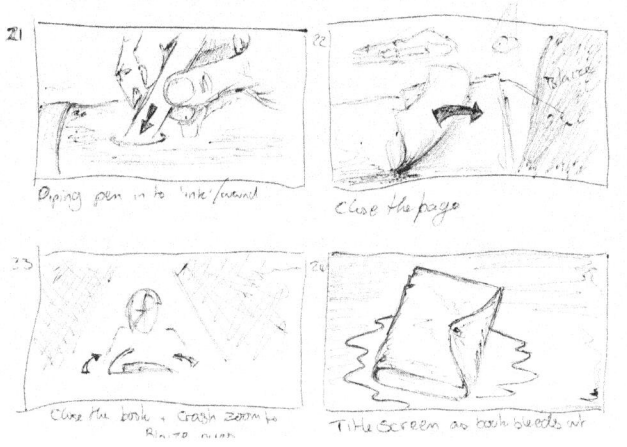

During production there was initially a tenth segment but unfortunately it fell victim to saboteurs. Chris Yardley sadly never managed to film his version in Glasgow and handed over the reigns to Lord Zion, who shot and completed the segment. However, once the film was edited and ready to promote, saboteurs once again reared their ugly heads and caused us to unfortunately scrap the cursed segment, luckily some of the footage Zion directed was salvaged and spliced in to Beer Cellar and Precious. Perhaps we will remake this segment for a possible sequel, Blaize has many more ideas and hopefully we will work together again.

Chris returned to the project to create the overall end credit sequence. With so many films involved in the project, getting the right style of credits was a tricky one that took a year to put together. Instead of scrolling text like the majority of films made, we opted for a page system allowing for us to have an entire segments information per page, intercutting the credits with a sequence directed by Chris, enabling him to bring back some of the elements he was planning to incorporate in to his cancelled segment revolving around a Satanic estate agent luring a naïve couple to their doom. After the saboteurs had caused their damage, the end credits had to be tweaked, it was decided to incorporate similar backgrounds for the text to match those used as titles during the film, this enabled the credits to feel more connected to the rest of the anthology.

During post production, as each film emerged complete, we decided that individual segments could be released to short film festivals and basically act as teasers for the full anthology. This worked really well, every segment was submitted and we received quite a response, I was very pleased that we had a lot of world wide acceptances as well as two nominations, one for best FX and one for Best Short, the shorts continue to do the rounds at conventions and film festivals, each time bringing more awareness to the full anthology and to the work of Blaize.

The anthology has been a long journey for me and one that has taught me a great deal, I always plan to learn something with every project I undertake and this was no different. I am honoured to have worked with so many talented people, their support and patience with the ongoing edits and unforeseen problems encountered has meant a great deal to me. But despite the issues we now have a great film and one that I am certainly proud of. My only hope is that we have done justice to the work of Blaize-Alix Szanto, she is a talented writer and has a twisted mind that I hope continues to spill out on to paper and film.

This book started as a film making journal but I hope it also serves as a platform for her to go to greater things as well as give an insight in to the production of an independent Horror Anthology that aspiring filmmakers can enjoy and hopefully learn from.

Many thanks for reading.

For more information of Blaze of Gory please follow the links below.

Official Facebook Page

Official Twitter

Official Trailer

Credits

Executive Producer
David V G Davies

Produced by
MJ Dixon, Andy Edwards, Simon P Edwards,
Robert Noel Gifford, Anna McCarthy, Antoni McVay, Jason Wright

Co Produced by
Duff Eynon, John 'Bam' Goodall, Rob Leese Jones, Yana Kolesnyk, Kirsty Richardson,
Vikki Spit and Lord Zion

Associate Producer
Dean Sills

Opening Titles by David V G Davies
featuring Blaize-Alix Szanto as herself and Michelle Henderson as The Body
Prosthetics by David V G Davies
Make up by Lucy Claire Brennan
Music by Benjamin Symons

End Credits by Chris Yardley
featuring David Magowan as John, Nicollete McKeown as Sarah,
Alan Cuthbert as The Estate Agent
Directors Of Photography Jordan Whitefield & Chris Yardley
Sound Amy MacKinnon
Visual Effects by Chris Yardley
Music by
Figure In Black

Footage from Animal Soup (2009) and Monitor (2011)
used with permission from Film MA

Footage from Meet the Cadavers
used with permission from Cold Slab Pictures

Footage from Demon Mist (2014)
used with permission from Silent Studios

Footage from Sola Gratia (2011/2012)
used with permission from Fear Driven Films

The Executive Producer would also like to thank

I can't thank you all enough for the support everyone has given me throughout the making process.

As well as all those who have been listed above I'd like to thank in particular my friends and family who put up with body parts being made in the workplace and at home.

To everyone who has retweeted, followed or liked any post that has been uploaded. To the Crawley News and the BBC. To UK Horror Scene, To Dean for interviewing us.

To GBH Mark for instigating the search for stories.

To all who donated to the cause.

To Big Fat Greg for tech support

Eve Yarnton

Everyone who stepped in last minute to assist.

To all those who auditioned but for whatever reason, didn't make it.

Team Impact, thanks guys, a pleasure working with you as always.

To all the cast who have endured all manner of nastiness and have done so with smiles and enthusiasm and have delivered the most amazing performances I've ever witnessed.

The Crew, you guys have been fantastic and have given so much.

To Lea-Anne Szanto,
For creating the demon spawn and encouraging her to send me the first story.

To Blaize-Alix Szanto,
Young lady, you are going to go far, you have amazing talent and I hope we have done you proud, go forth and conquer,
just remember you said we can have more stories for a sequel!

To the saboteurs, may you get your well earned comeuppance

Thanks
www.freesfx.co.uk
www.videoblocks.com
www.videocopilot.net
freesound.org
www.TeamImpact.tv
www.DamoclesFoundation.com

additional thanks to
Dugg Danes, Donnie Johnson, JAK, 'Goblin' Pete

All characters appearing in this work are fictitious.
Any resemblance to real persons, living or dead, is purely coincidental.

The use of Team Impact in this film is used with permission and is done for entertainment purposes only and is not a true representation of their work ethics and is purely used for NAME only and is not intended to bring disrepute to them in any way whatsoever

The Damocles Foundation is a fictional company from the film Monitor (2011) directed by David V G Davies and does not represent any existing company.

No animals were harmed in the making of this motion picture

www.ingramcontent.com/pod-product-compliance
Lightning Source LLC
Chambersburg PA
CBHW071420180526
45170CB00001B/168